One World
One People

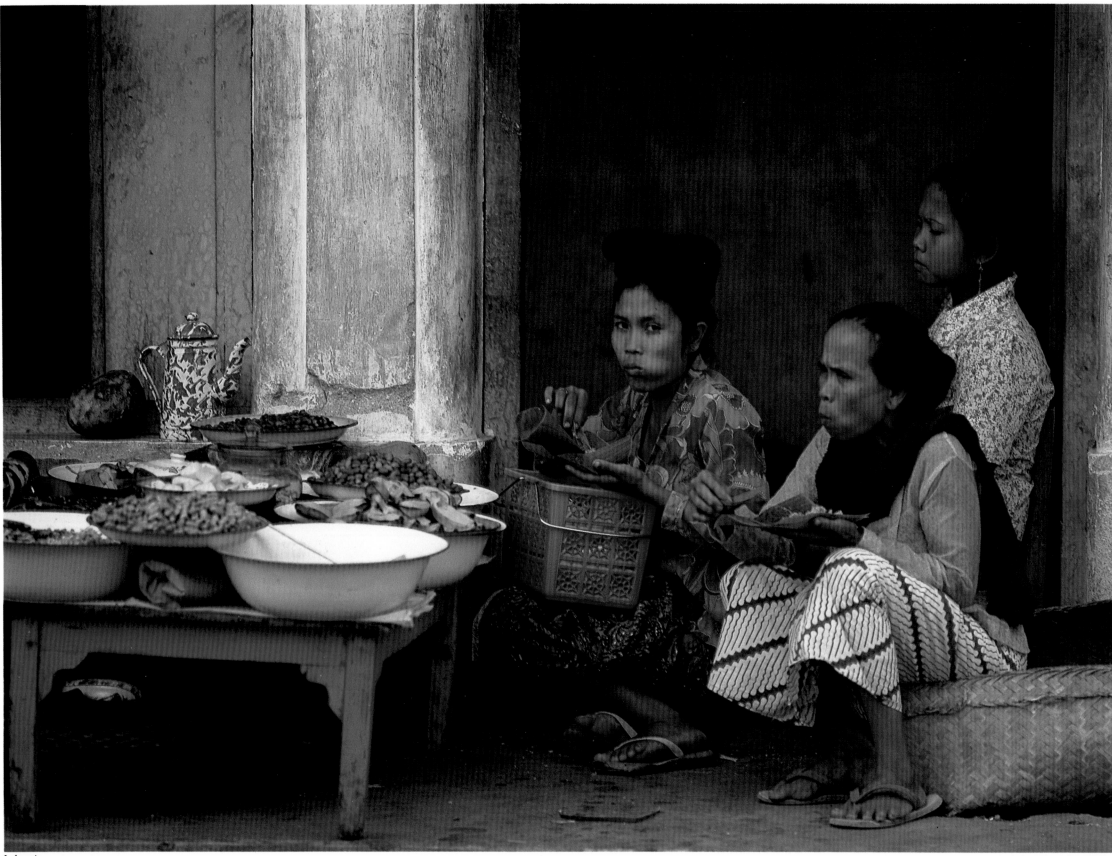

Indonesia

ONE WORLD ONE PEOPLE

A COLLECTION OF PHOTOGRAPHS AND ESSAYS ON THE POWER OF THE HUMAN EXPERIENCE

PHOTOGRAPHS BY YOSHIAKI NAGASHIMA. WORDS BY ROBERT WHITE AND KOICHI SHIMAZU WITH JOHN JONES. CAPTIONS BY JOHN POPPY.

Published by ARC International, Ltd., Tokyo and San Francisco

Distributed by Kampmann & Company, Inc., New York

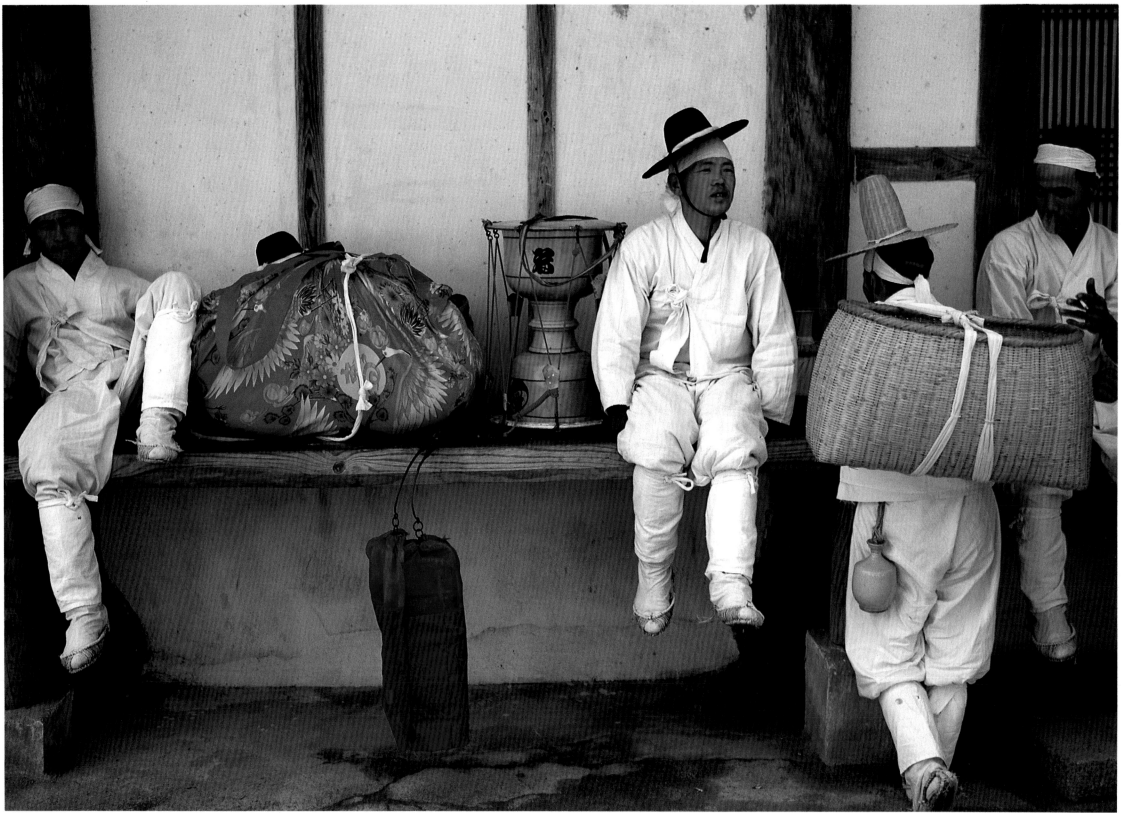

Korea

CONTENTS

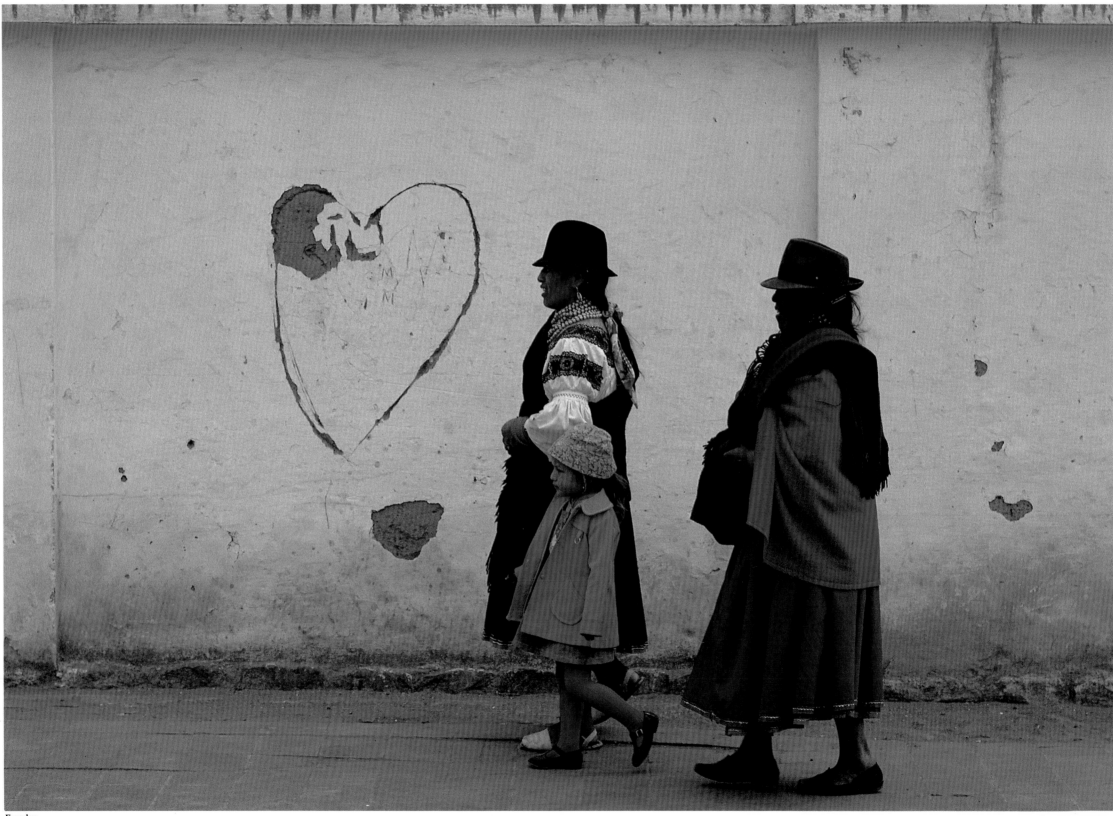

Ecuador

Most of the world's languages now have a saying that expresses the thought in this Japanese proverb: "The world seems large but is small." Such proverbs are not ancient, because less than two hundred years ago—before the great technological leaps forward in transportation and communication—the world *was* large. The lives of people across an ocean, or just a few miles away across a mountain, were largely a mystery, since there was no way to contact them. People now can move around our globe in a matter of hours; they can communicate with each other in a matter of seconds. Business and political leaders and others concerned with the human condition know that the rise of the multinational corporation and the increasing interdependence of economies, along with the development of the means to destroy literally all life on the planet, make it imperative for the world's people to find ways of living together better.

The photographs in this book show that within the diversity of human life, there is unity. In the important aspects of life, there are more likenesses than differences. We are one people, and the energy captured in these images shows the power and the oneness of the human experience.

This book is the product of three separate inspirations. The first occurred more than twenty years ago, when photographer Yoshiaki Nagashima was a young man. He was taken to see the exhibit of photos called *The Family of Man* (later published as a book). The pictures spoke to his heart. He was so moved by the message—the universality of human experience—that he determined he would become a photographer and speak to others' hearts.

Robert White, an American entrepreneur living in Toyko, was the next to be inspired, though it was a near

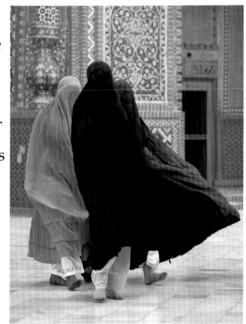

Afghanistan

miss. In January, 1981, White was invited to attend the opening of an exhibit of Nagashima's photographs. He went reluctantly, never having been a fan of photographic art and expecting to be bored by the cocktail party chatter of an opening. Instead, the photos were a revelation. He was transfixed by the beauty of Nagashima's work, and he saw in the photos a graphic metaphor for the personal growth theme of his organization's programs.

Koichi Shimazu, White's partner in a firm that focuses on human relations and organizational excellence, was the third to be inspired by the photographs. He saw in Nagashima's work a statement that reflected the basis of his own work with White—that national and cultural differences need not be barriers to true understanding and cooperation among people, that there is indeed a world community that needs nurturing. Shimazu and White have successfully transcended the differences between their backgrounds, and those of their multinational staff, in their own firm. As a further expression of cross-cultural cooperation, this book is being published both in Japan and in the United States with a team of professionals from both societies.

What we want to say in sharing these thoughts and images is that all of us need to take our world citizenship seriously. While we are sensitive to the many threats in the world today, all three of us retain a clear optimism about the ability of people to make their lives work better and to improve the lot of the human community. Understanding how we share the planet with so many others who have the same dream helps us to find the courage to reach out, to share, and to grow in the process.

Yoshiaki Nagashima, Koichi Shimazu, Robert White
Tokyo, April 1984

PREFACE

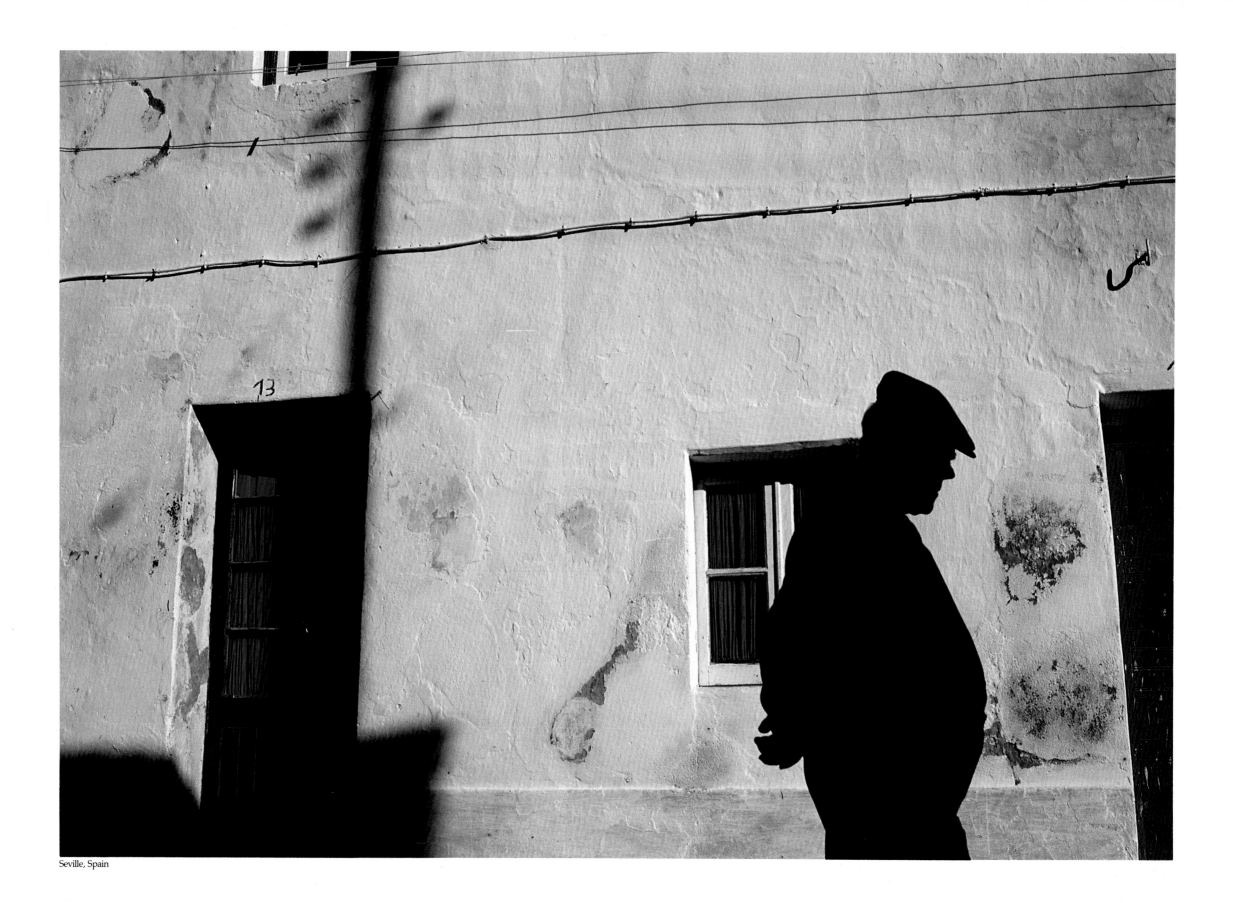

Seville, Spain

EVERY HUMAN HEART IS HUMAN.—*Longfellow* So many of our business, national, and international affairs center around apparent cultural and political differences among people that we tend to forget or ignore our likenesses. If the world works, it is because somehow its people are able to communicate with one another—when they have the opportunity and the incentive. Although each of us is unique, we all go through the same life cycle and celebrate birth and growth and love. As Montaigne said, "Every man carries the entire form of the human condition." None of us is impervious to what is happening in the world, and we clearly need each other to survive in it.

Seeing the humanness of people is affirming that "We are family." Acknowledging our interdependence is accepting that we are more alike than we are different, that our global human need is to find new social bonds in a time characterized by stress and strife. President Kennedy said it very well: "In the final analysis, our most common link is that we inhabit this small planet. We all breathe the same air. We all cherish our children's future. And we are all mortal."

This book is about all people. It focuses on the power of human experience by illustrating the common

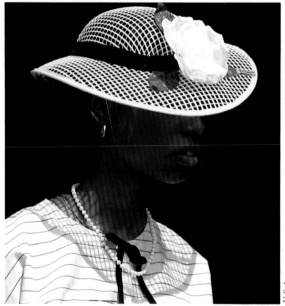

U.S.A.

threads that bind humanity, the likenesses that make it possible for us to cohabit the earth. It traces the path from infancy through childhood, and it depicts how people renew themselves as they move through the life cycle. The first part of the book is arranged around stages of development and how people become individuals playing their parts in a social network. The second part focuses on the skeins of that social network—family, work, leisure, worship, celebration—and on the need for some times of solitude to weigh and balance one's wishes and responsibilities. The third part depicts the stages of life that Erik Erikson characterizes as ages of "generativity" and "integrity"—the later parts of life, when wisdom is shared toward life's renewal.

The treatment is unabashedly positive. It is time for people to see the world's inhabitants as their brothers and sisters. As the book unfolds, a realization of the idea of "One World, One People" comes into consciousness. We can identify with the people in each photograph. A mother in Harlem, in New York City, carries her baby into the spray of an open fire hydrant, and her "sister" nurses her baby in a park in Germany. It is all a part of what binds us together, the power of the human experience.

INTRODUCTION

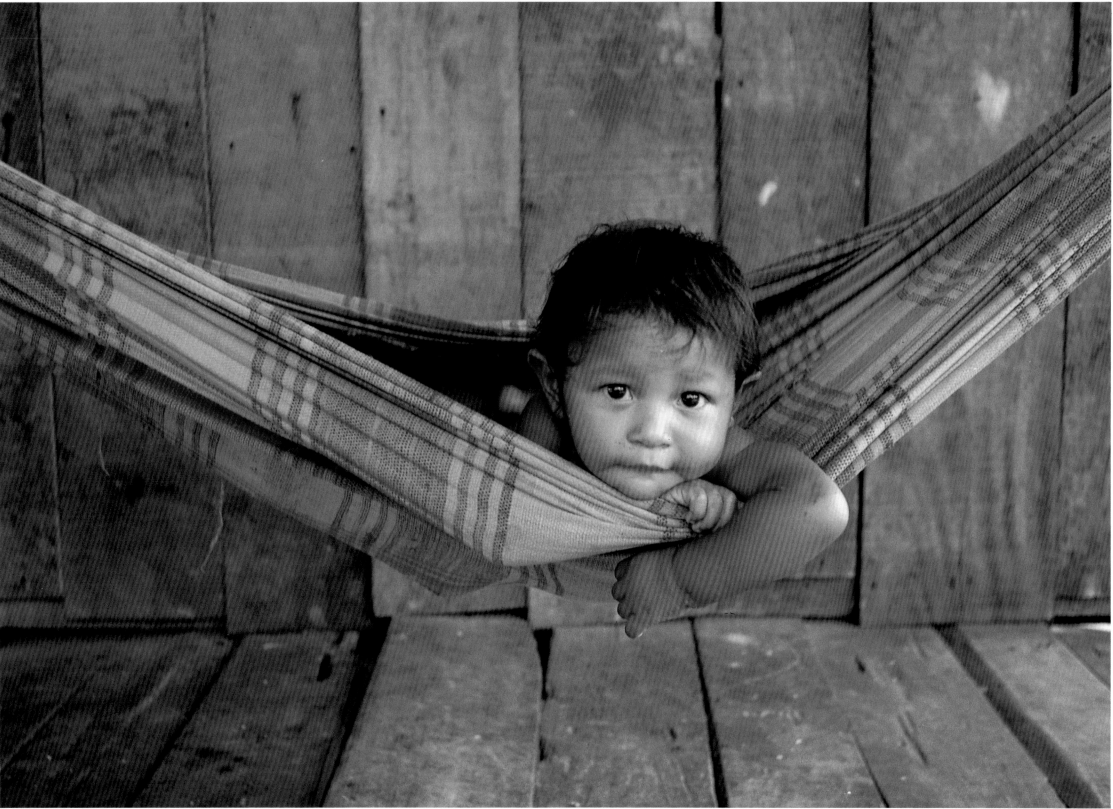

Ecuador

Y OUR CHILDREN ARE NOT YOUR CHILDREN. THEY ARE THE SONS AND DAUGHTERS OF LIFE'S LONGING FOR ITSELF. —*Kahlil Gibran* Few of us ever lose our fascination with watching young people grow and learn. We cherish their innocence, trust, and curiosity. As infants emerge into self-consciousness and develop unique personalities, each day brings new discoveries. Across nations, races, and religions, we all go through much the same processes of growing, learning, and play. If we look closely at children all over the world, we can see a connectedness that could guide us all our lives. Have you noticed how children from widely different cultures quickly learn to play together? We could choose to learn from them.

The mother-child connection is probably the strongest human bond. Mothers the world over gladly take the responsibility for nurturing new lives. Children are eager to learn about their world, and in the course of their daily activities together, mothers guide their children as the children absorb the environment around them. The child becomes oriented to the world, and in the process develops an individual personality, a self. Growth into human consciousness can be frustrating and painful, but growth itself is empowering. Youth is a time of emergence and discovery, of beginning, defining, and breaking away.

Awareness of self brings a consciousness of choice, and if children learn that they are "cause," that they can indeed create their own worlds, they can feel the sense of personal power that is available to us all. But if their awareness omits learning about their membership in the world community, they will contribute to the continuation of a divided planet.

Here, then, is the paradox the young person must live out. We must discover ourselves as individuals, yet we must find ways to understand our connectedness with each other and with the universe. Bruce Barton stresses the first part of the paradox: "If you have anything valuable to contribute to the world, it will come through the expression of your personality—that single spark of divinity that sets you off and makes you different from every other living creature." The other part of the paradox is illustrated by George Bach: "We experience expansion as awareness, comprehension, or whatever we wish to call it. When we are completely expanded, we have a feeling of total awareness, of being one with all of life. At that level, we have no resistance to any vibrations or interactions of other beings."

The child's emergence is a quest both inward and outward. As we unfold our consciousness of our uniqueness, we search for meaning in the larger world we inhabit.

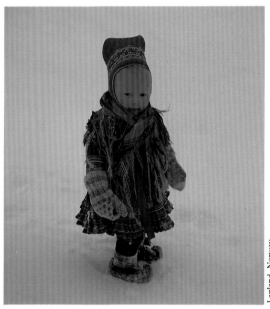

Lapland, Norway

Children face a world that requires them to have the courage to ask hard questions. We owe them the chance to find answers. Perhaps Stewart Emery said it best: "The greatest gift we can give our children is to allow them to discover that what they are works. If you can support a child in finding out that all he has to be is himself—that what he is is enough, you have given the greatest gift of all."

A CHILD WENT FORTH

MIRACLES OF BEING

Looking back from middle age, Oriana Fallaci said that one of the most important things she had learned was "to love the miracle of having been born." That miracle is transparent when we see children playing and learning. Very young children enchant us while they amuse themselves, using fantasy to create worlds. Just draping a colorful rag over your shoulders can make you a prince. A best friend, always cooperative, can be created out of thin air. These games of imagination are sometimes opaque to adults. The Little Prince, a fictional child created by Antoine de Saint-Exupery, spoke for all children when he said, "Grownups never understand things for themselves, and it is tiring for children to be always and forever explaining things to them."

The photographs in this section show children both playing and working, since work is a natural part of children's lives in some cultures; in others, school is children's work. In either case, the learning that began in infancy, with getting to know how the parts of one's own body work, continues.

Children learn a lot just from watching their mothers do ordinary, everyday activities. A child and a mother, whether in a German park, at a market in Bolivia, or at a place of worship in Syria, have a special bond. They can share the joy of the child's daily discoveries. They can teach each other patience. They can learn how to love without qualification—love enough to let go when the time comes.

Learning does not end with the end of childhood, of course. Part of our genetic inheritance as human beings is our plasticity, our ability to learn and to make changes in ourselves based on what we have learned. Childhood, however, is seen everywhere as the most important time to give focus to growth and learning, as in education and training programs. What we teach young minds sets a course, establishes attitudes about the world and about work, and gives young people their concepts of themselves, which—in the absence of upheaval—often remain remarkably stable.

Children construct a self only in relation to their loved ones, their community. Human beings are social animals. We live and work together because our survival depends on it. Nagashima shows us our children in a way that illuminates the Japanese proverb: "No treasure surpasses children."

Man is a born child. His power is the power of growth.
—RABINDRANATH TAGORE

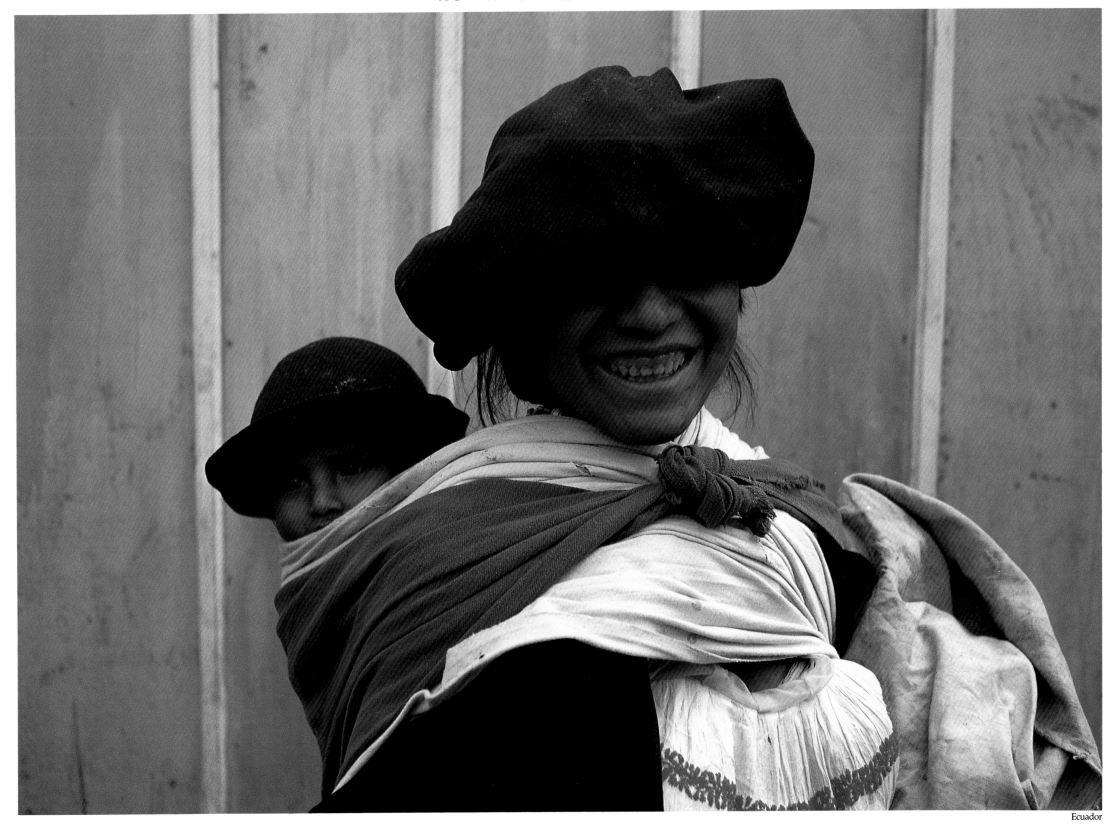

Ecuador

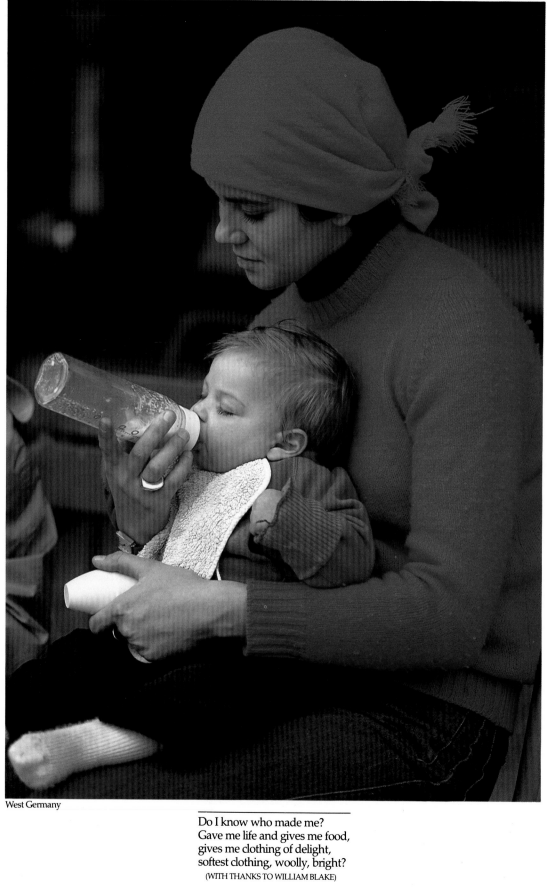

West Germany

Do I know who made me?
Gave me life and gives me food,
gives me clothing of delight,
softest clothing, woolly, bright?
(WITH THANKS TO WILLIAM BLAKE)

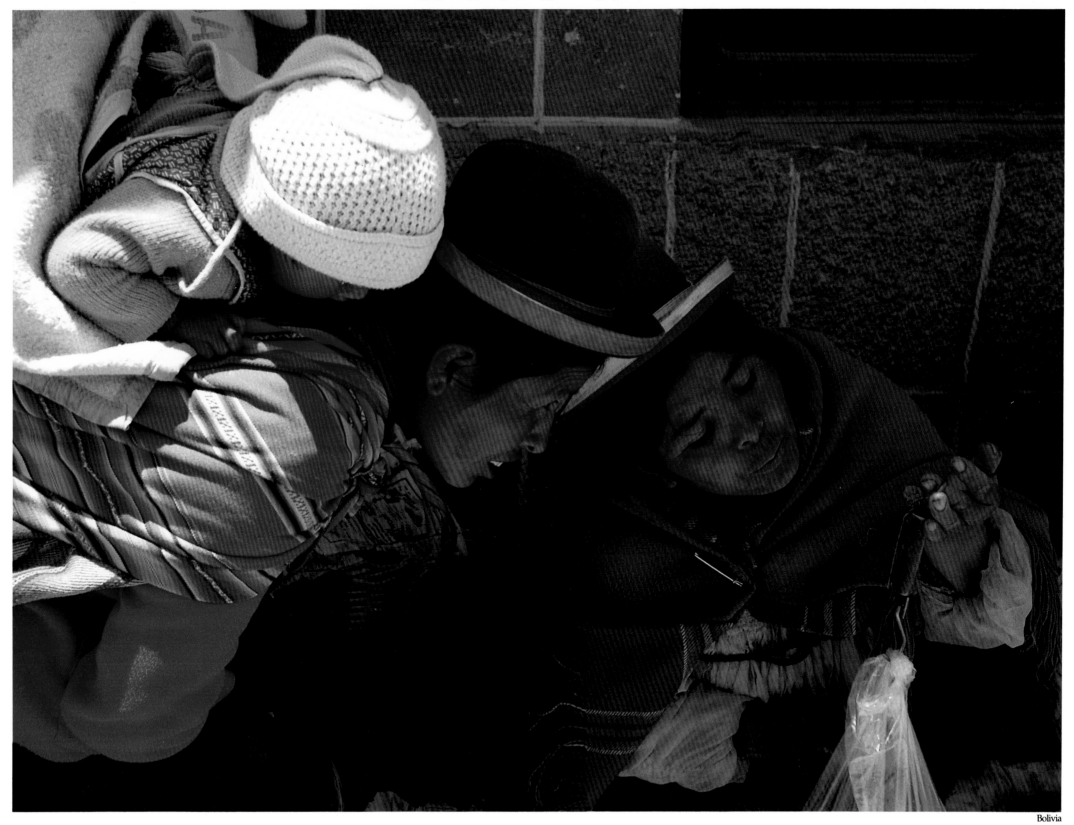

Bolivia

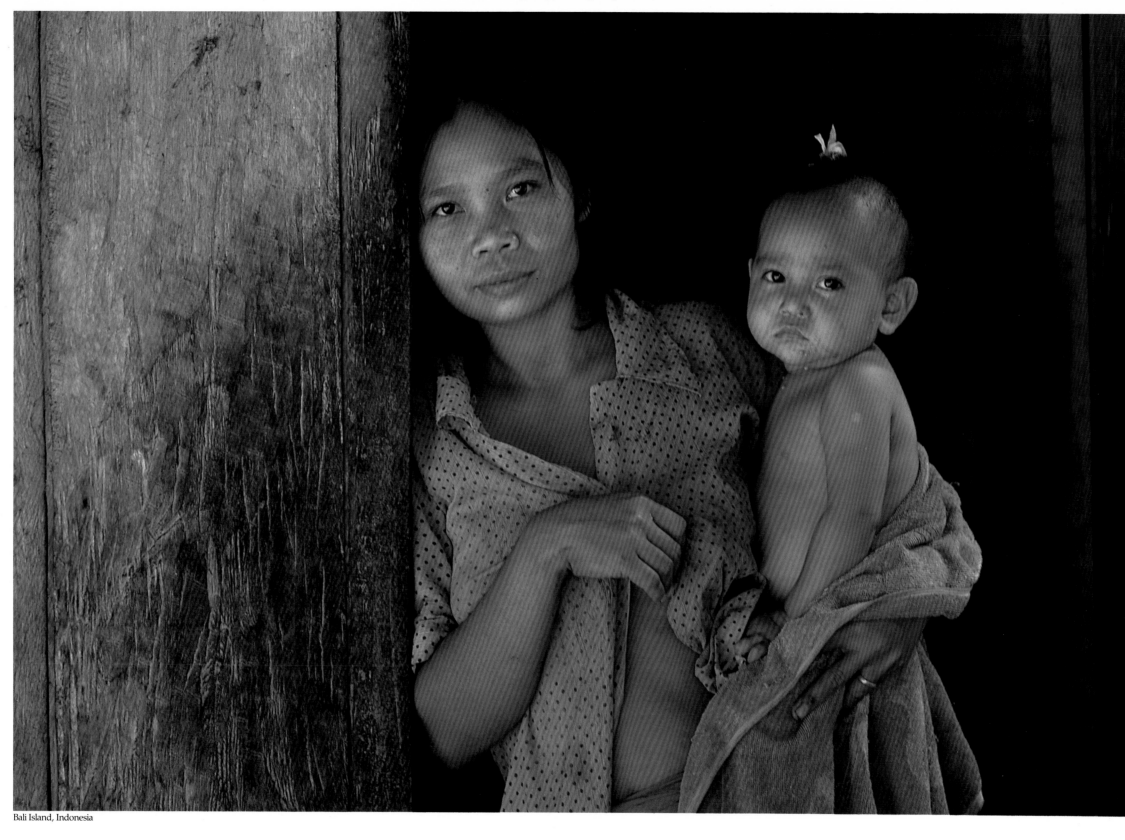

Bali Island, Indonesia

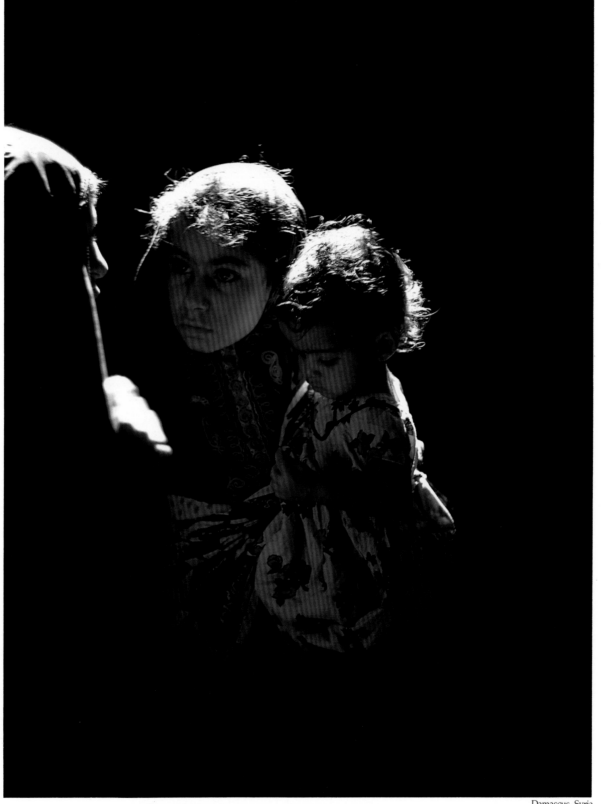

Damascus, Syria

Touched by all the light and darkness that we have,
the light of the heavens and of the earth,
light upon light,
I feel my mother hold me as a planet holds a sliding moon.

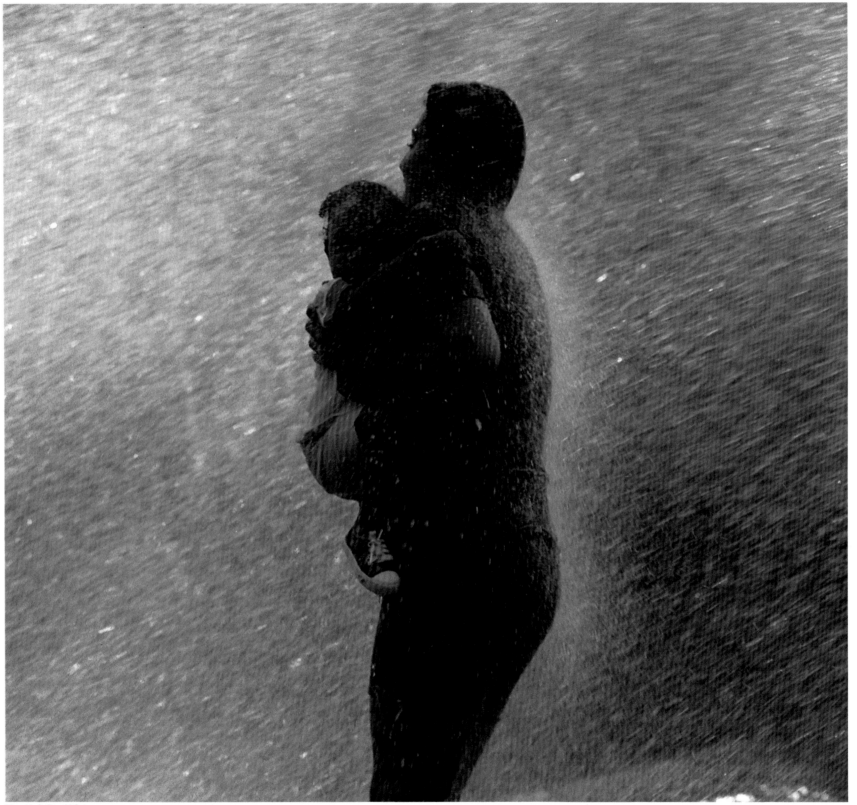

New York City, U.S.A.

Hold tight. Your body is my shield.
Water can clean, soften, cool; and from hydrants in the hot
concrete heart of a city, it can sting.
With you, I will go to meet it.

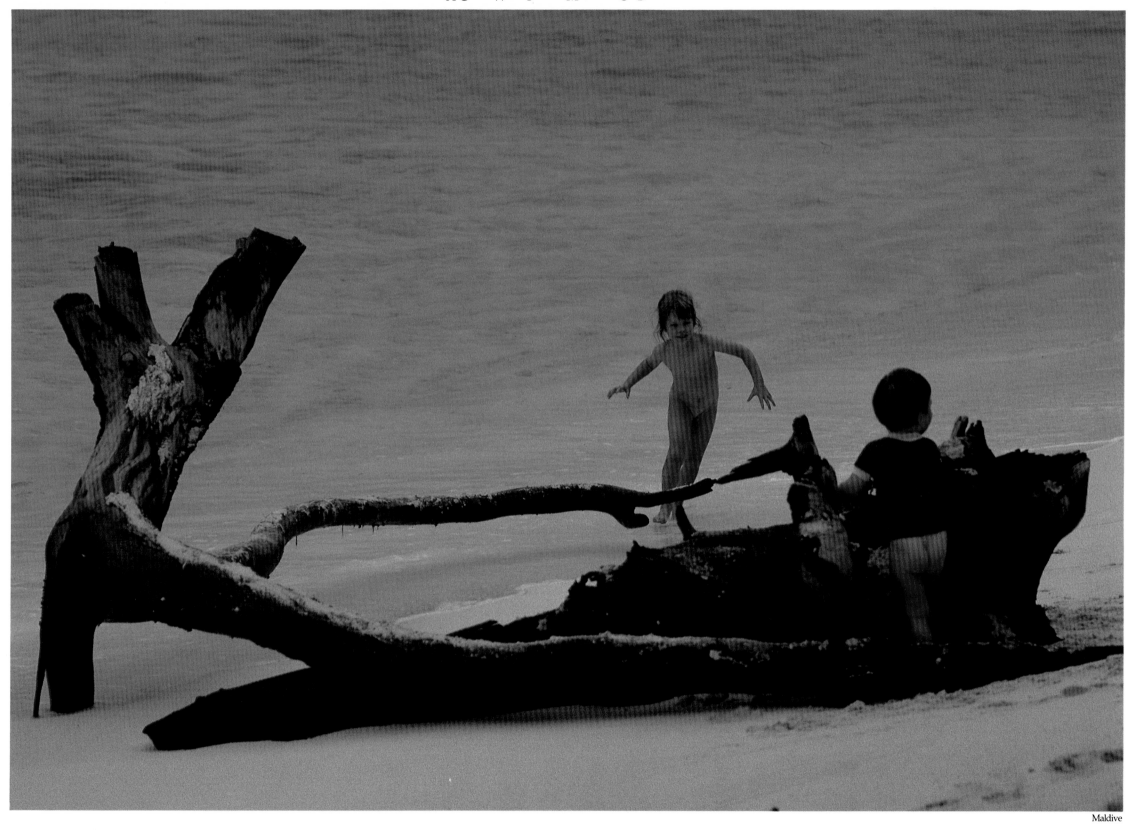

Maldive

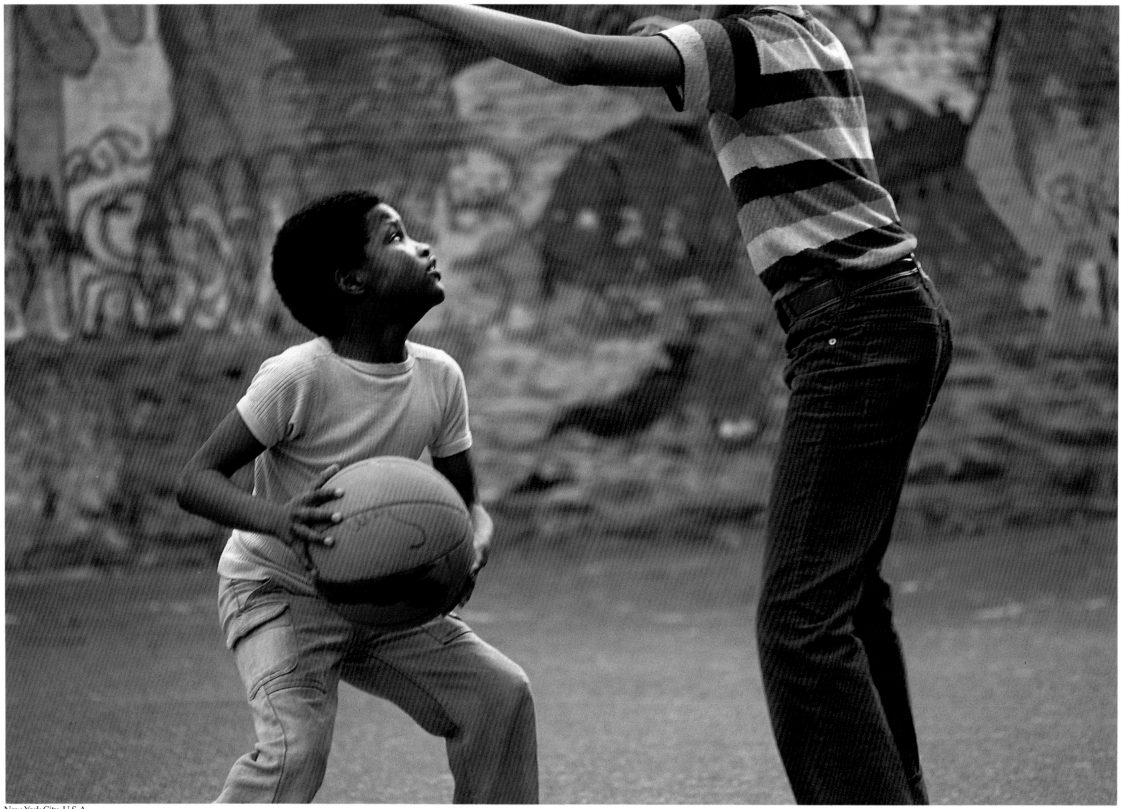

New York City, U.S.A.

You, so big, are in my way,
and without you I could not play.

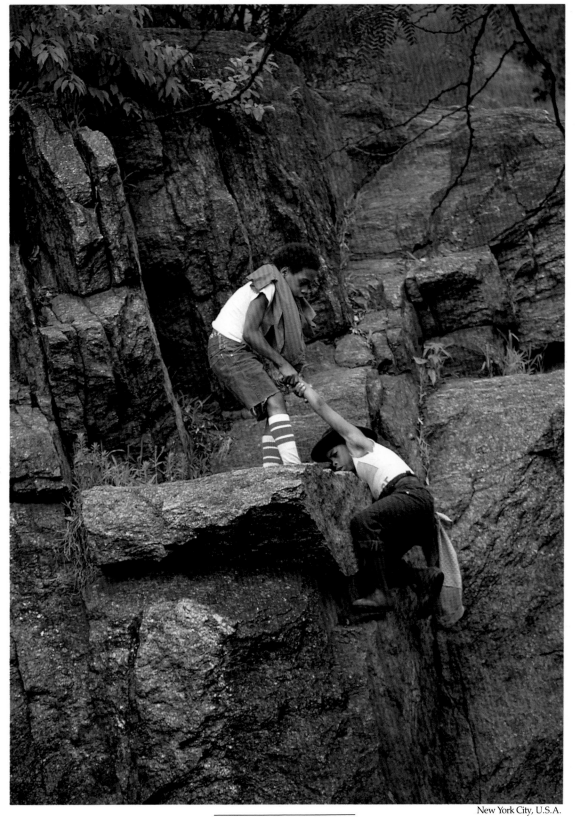

New York City, U.S.A.

Stretch a moment to its limit,
pull each other to the heights.
One more close call.

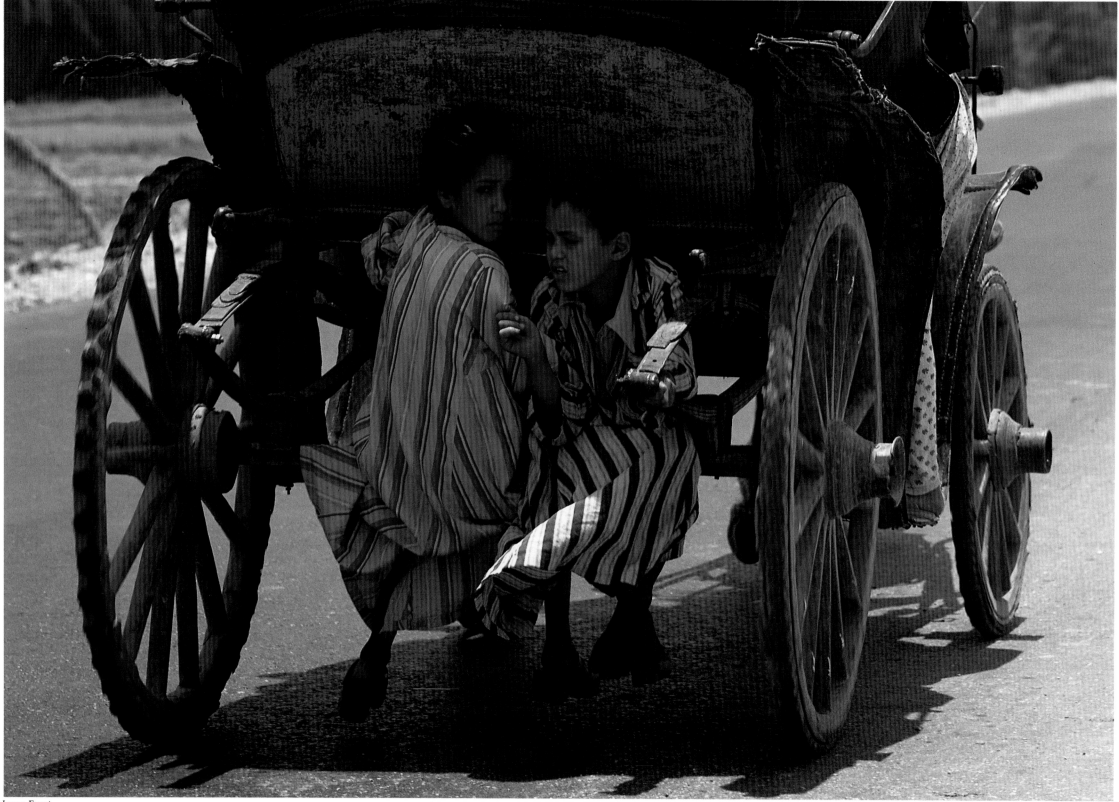

Luxor, Egypt

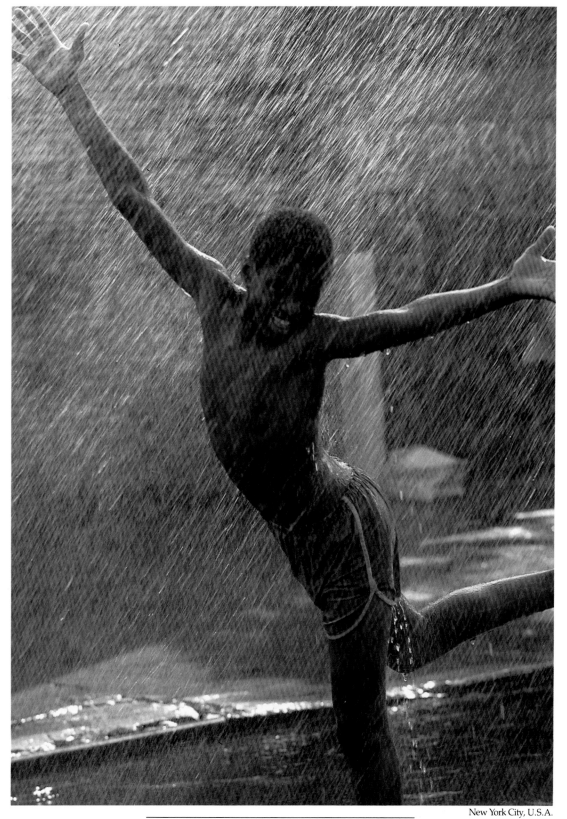

New York City, U.S.A.

Gleaming pavement, streaming spray, summer sunlight:
All the stage this dancer needs.

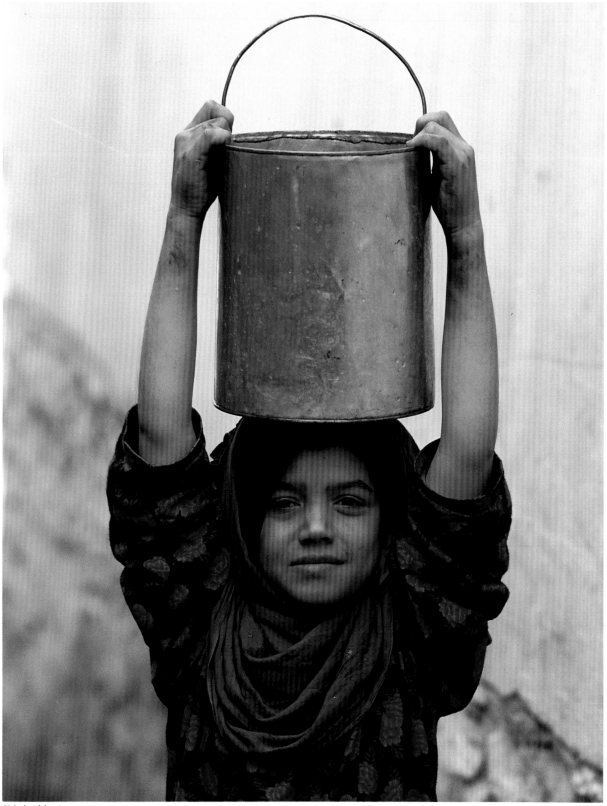

Kabul, Afghanistan

Already I know it, bringing water, kneading dough:
the greatness of work lives in every one of us.
The beginning of the work sets the crown on every ending.

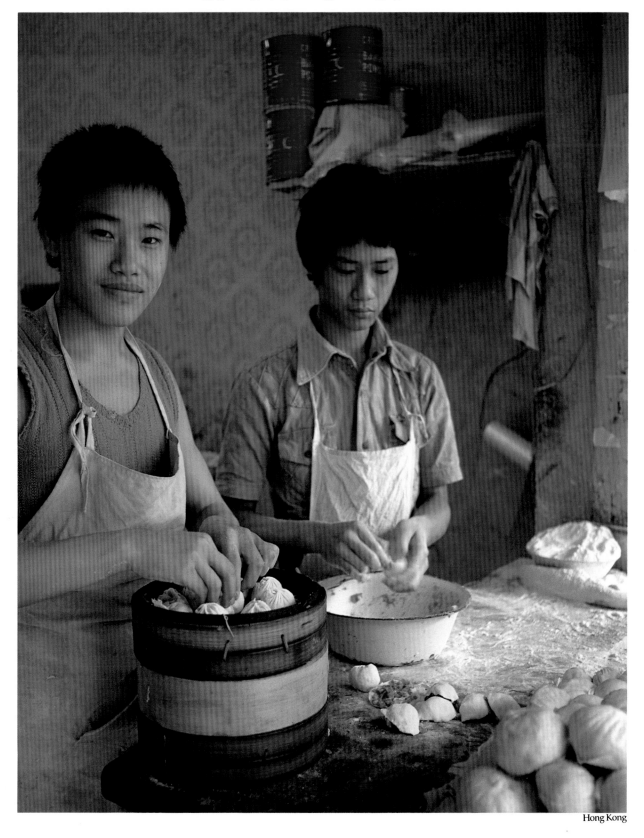

Hong Kong

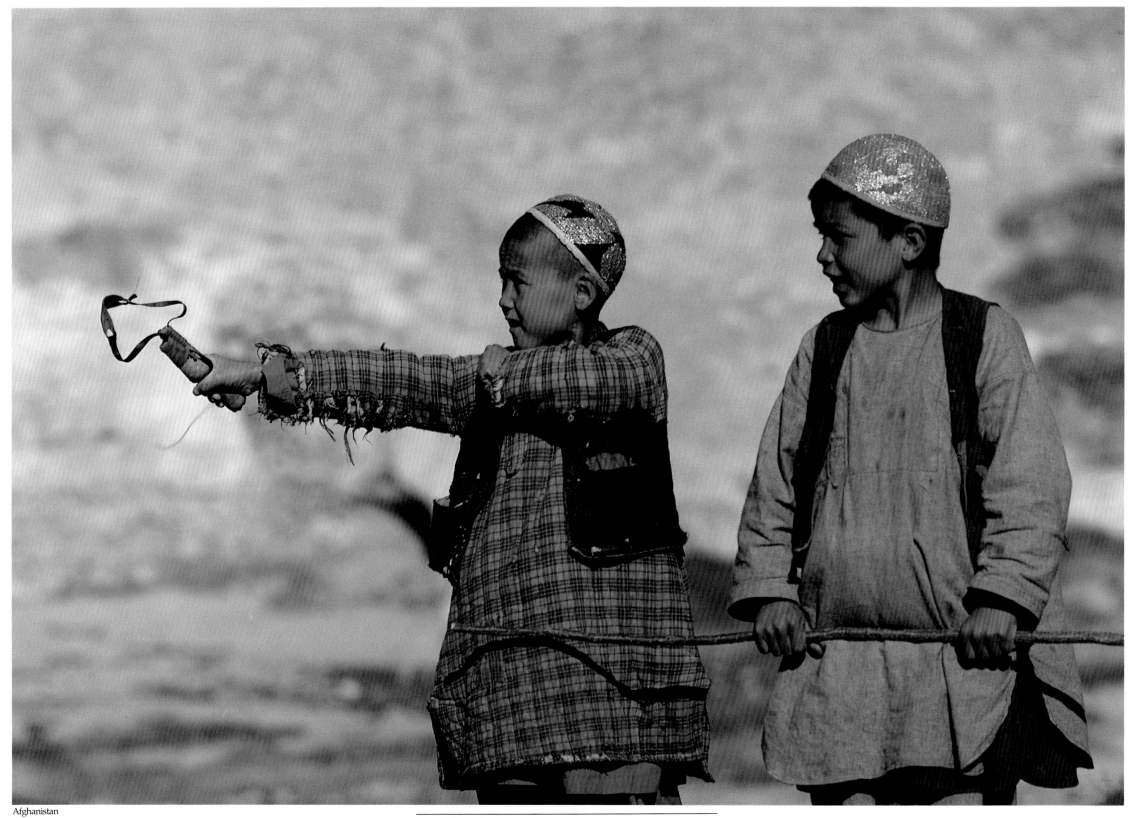

Afghanistan

We tend our family's sheep when around us
all nature seems at work or at war. A man might carry
a herder's stick in one hand, and with the other hold a weapon.
But this I have is still a toy. . . .

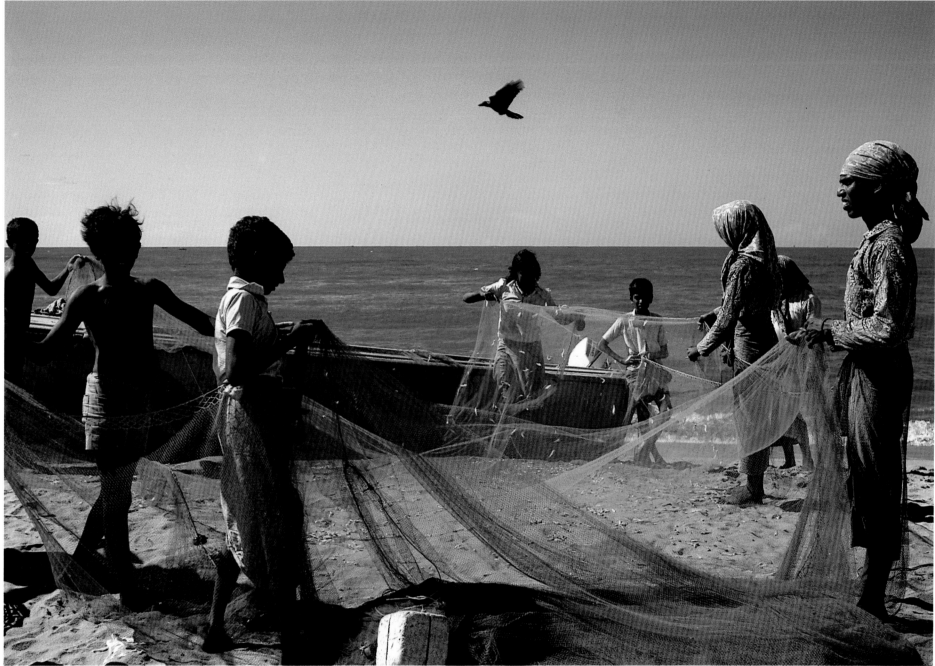

Sri Lanka

Daughters, sons, mothers, we live together within
the horizon of life. The freedom in a horizon is that
it is never quite at our elbows.

INSURMOUNTABLE OPPORTUNITIES

The passage from childhood to adulthood goes quickly in some parts of the world and more slowly in others. In some places, a ceremony of just a few hours marks the time when children stop being children and assume adult responsibilities. But in a growing number of places we detain young people in a phase called adolescence. We create a time for them to be what Erik Erikson called trapeze artists: they are suspended in air as they let go of childhood and reach toward adult roles. Cartoonist Walt Kelly had his most famous character, Pogo, speak for adolescents as they confront all the choices they will soon have to make: "We are surrounded by insurmountable opportunities."

The seemingly boundless energy of young people is a resource for these confusing years. Along with this youthful resilience, adolescents' best resource is each other. The photographs in this section give us a sense of the carefree abandon that characterizes this stage of life. We can see in these pictures remnants of childhood patched onto the fabric of adult concerns. Water seems to bring out the child in all of us, as several photos illustrate.

The young people Nagashima photographed performing on the street serve as a metaphor for most adolescents, who try on different roles all the time—sometimes with each other as audience, sometimes with an audience of only one, one's self.

Romance emerges during these years. We begin to explore intimacy with others. For many young adults, the exploration results in commitment, and that commitment is solemnized and universally celebrated.

We are the miracle of miracles, the great inscrutable mystery of God.
—THOMAS CARLYLE

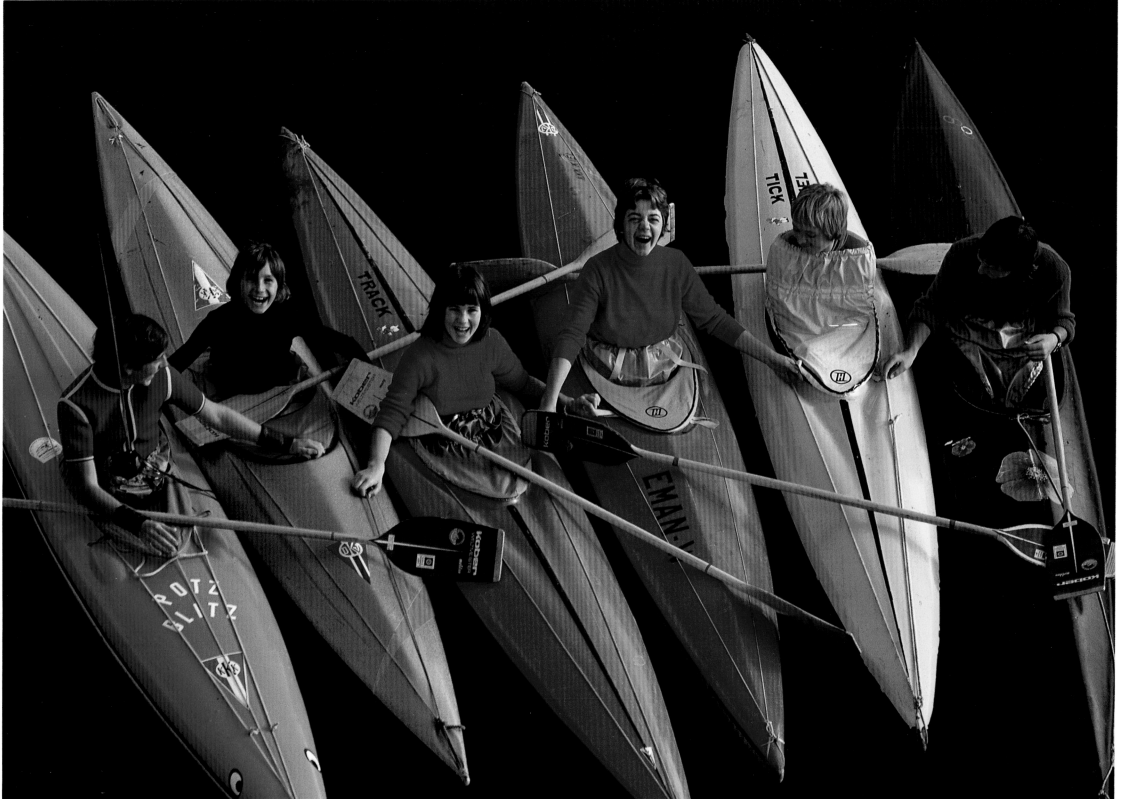

West Germany

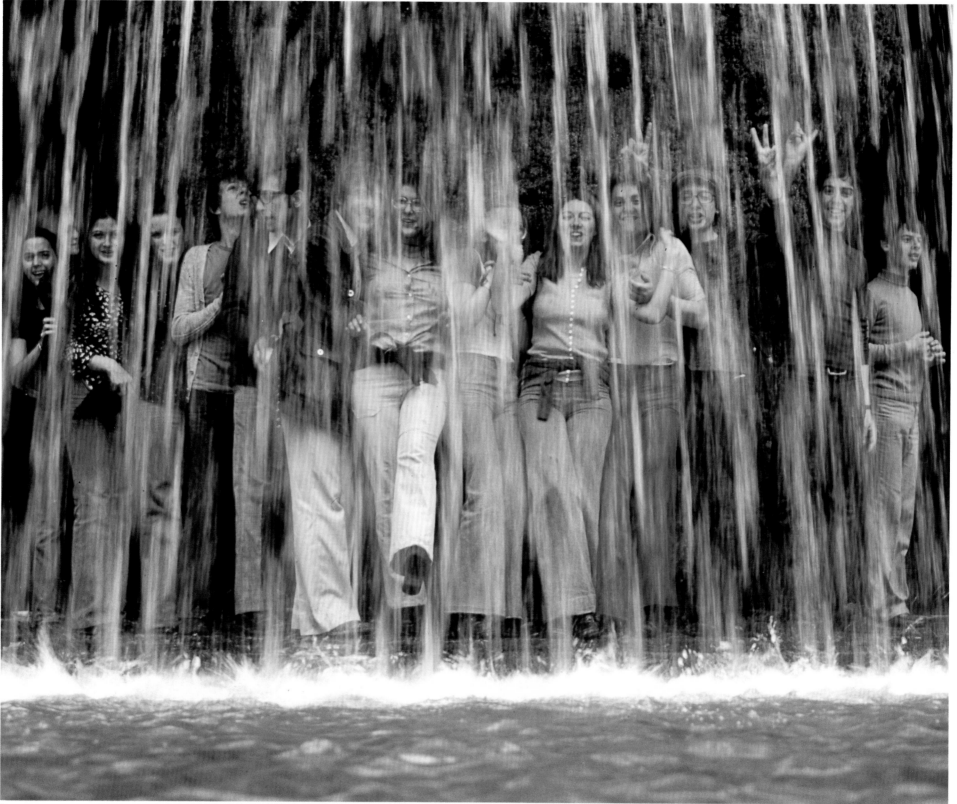

Rome, Italy

Bars of water line up the world in order. No . . . not bars. A cascading prism. Are those
your shapes dancing behind it, or ours? Never mind. Today we crowd in, hip to hip,
to greet, welcome, protect each other. We feel the touch of the one in the play of the many.

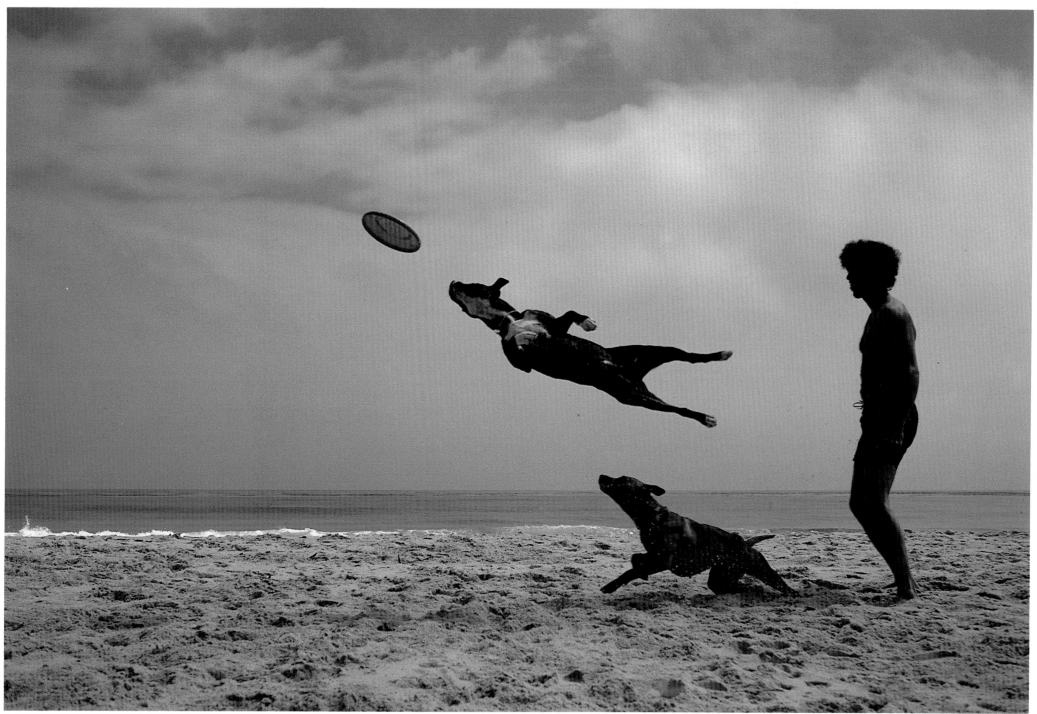

Carmel, California, U.S.A

To leap, to fly, to hold nothing back.

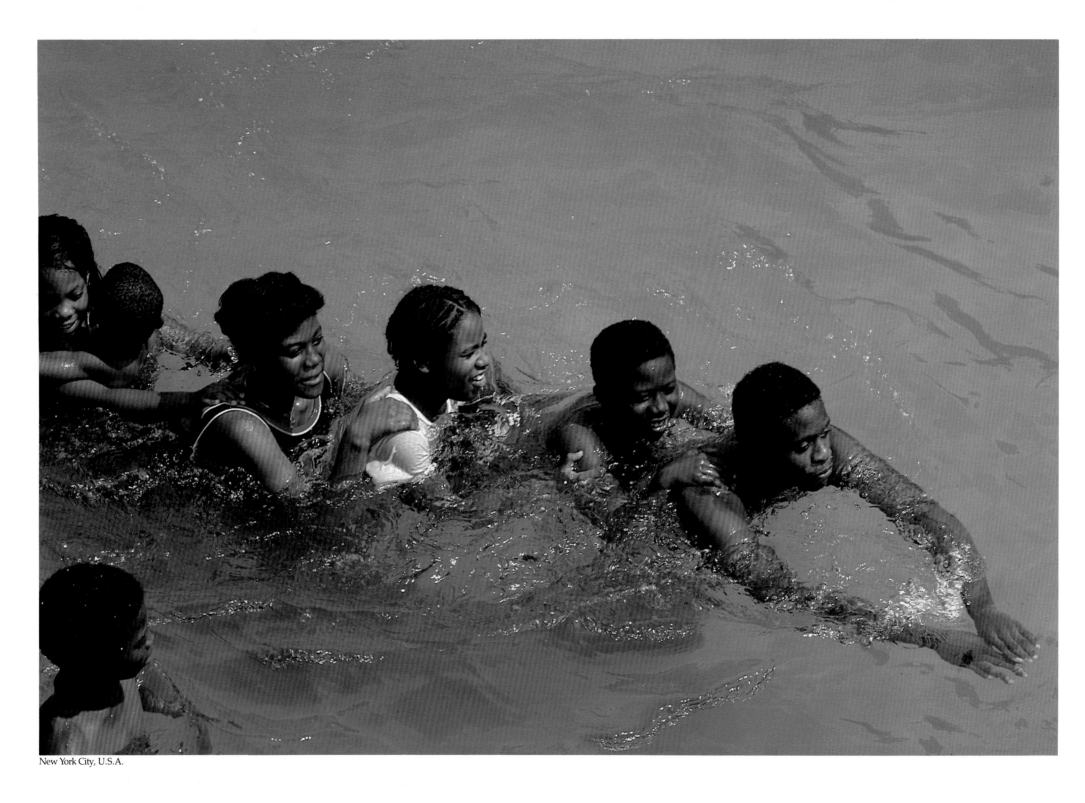

New York City, U.S.A.

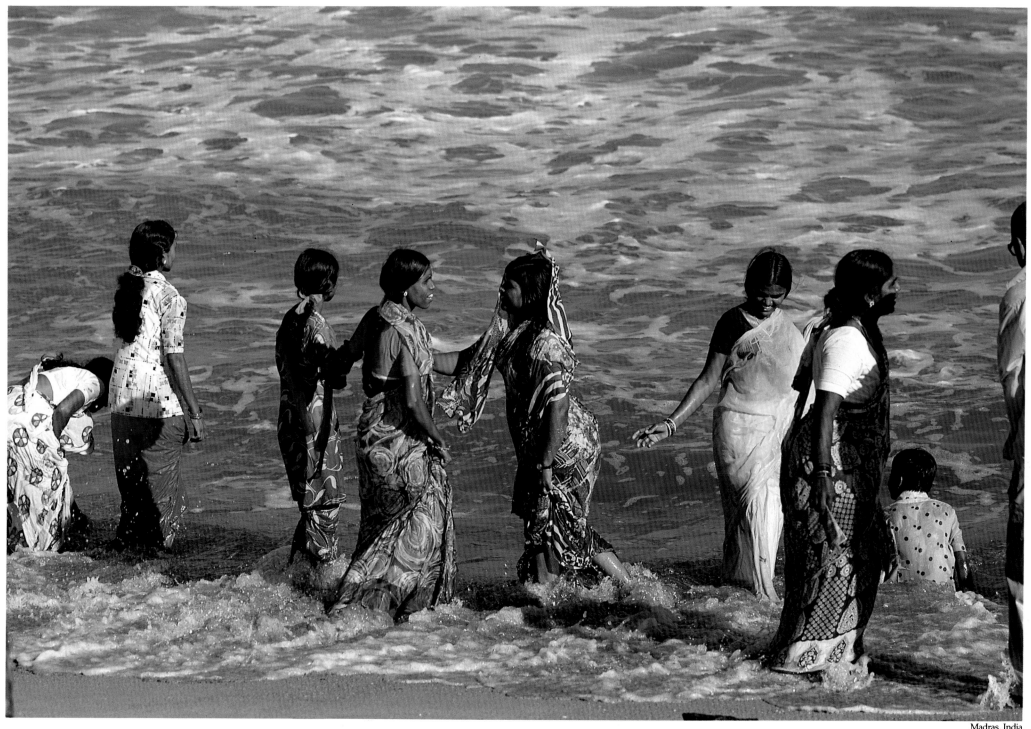

Madras, India

Oceans surge across seven-tenths of a planet plump with its own juices. Amino acids, purines, pyrimidines, and sugars in them combined three billion years ago to make a form of life. Foam at their edges eased the passage of sea creatures moving, 420 million years ago, to land. Blood as saline as the sea pumps through us now. We wear our brightest traveling silks to visit the old home.

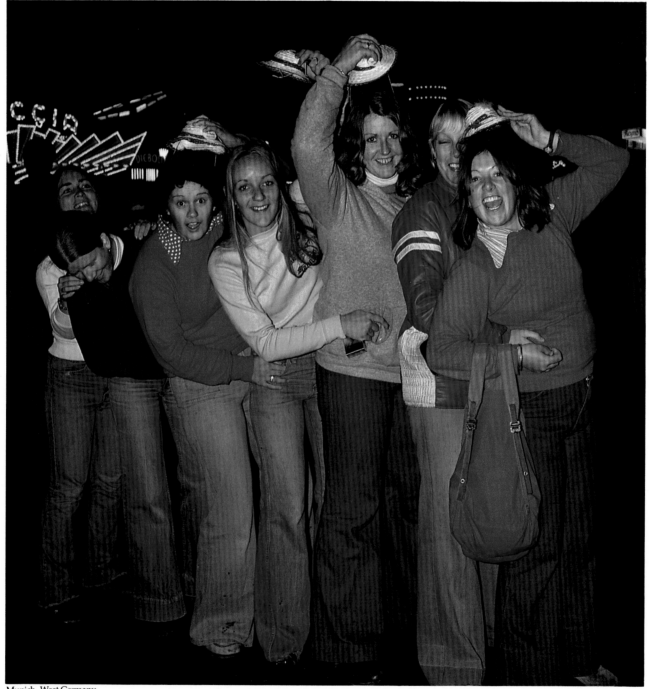

Munich, West Germany

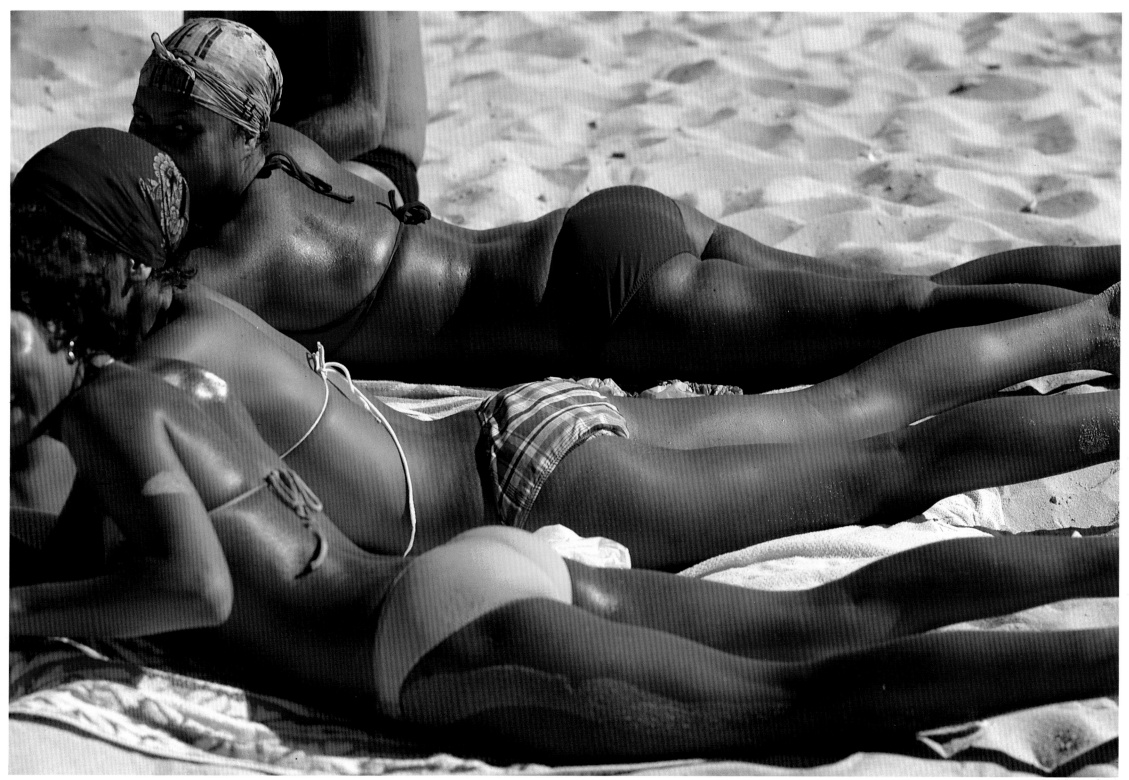

Rio de Janeiro, Brazil

The day after Carnival.
Echo of a samba in the sound of the surf.
Memories.

Paris, France

Paris, France

A lively youthful spirit once entertained us.
It comes again, when we let it.
Music, masks, all instruments of magic,
give form to our dreams as well as our desires.

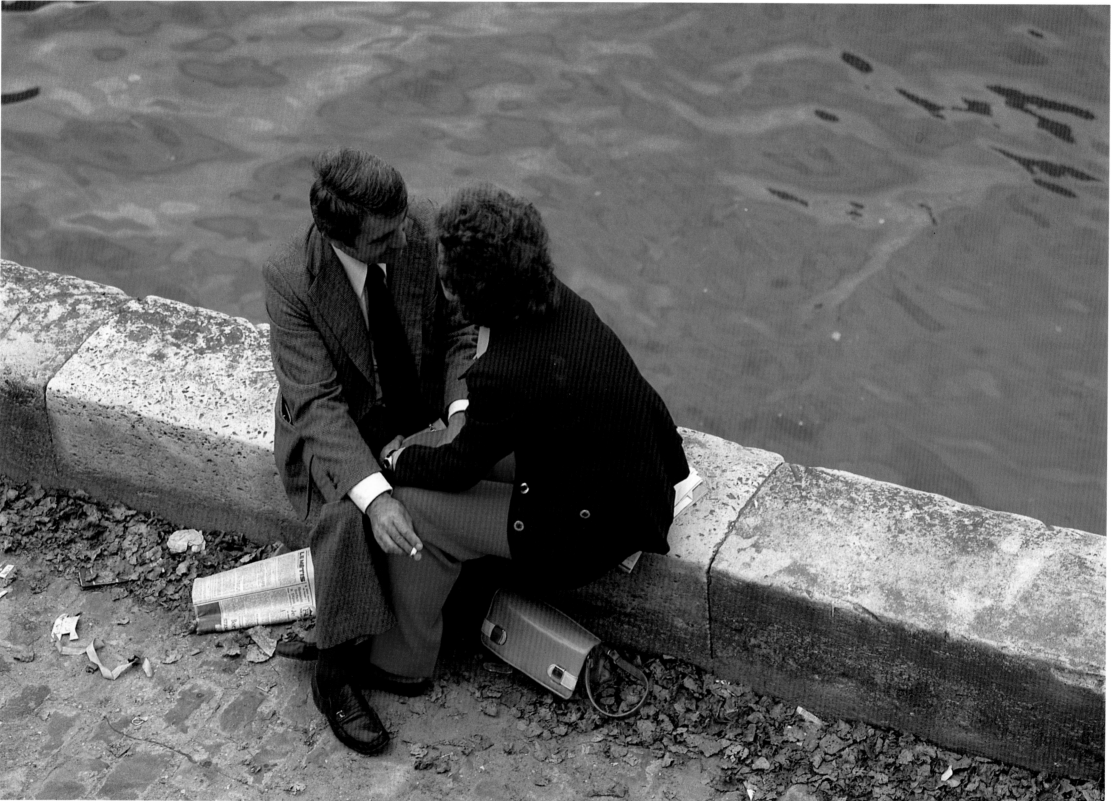

Paris, France

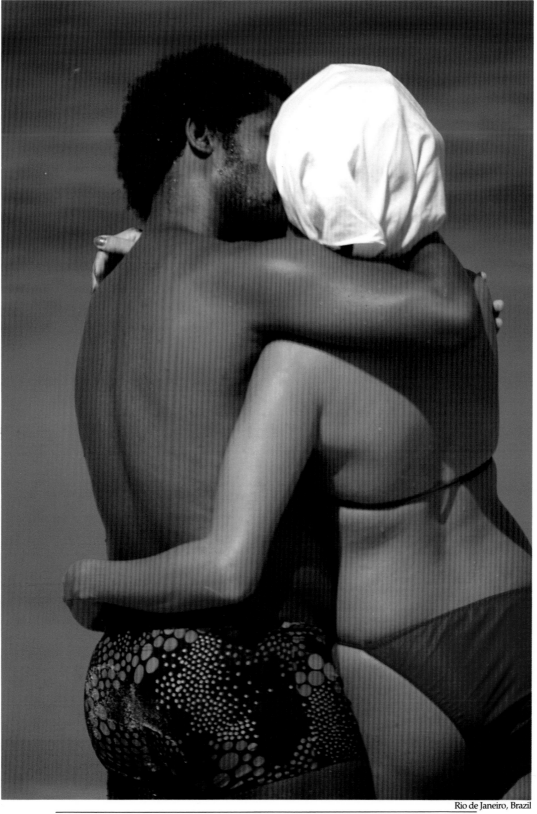

Rio de Janeiro, Brazil

We belong to the fellowship of those with a taste for romance, and the endurance to love.
To love is to encourage (hearten, embolden) as much as to enjoy; there is courage in
committing yourself to be a mirror for another soul.

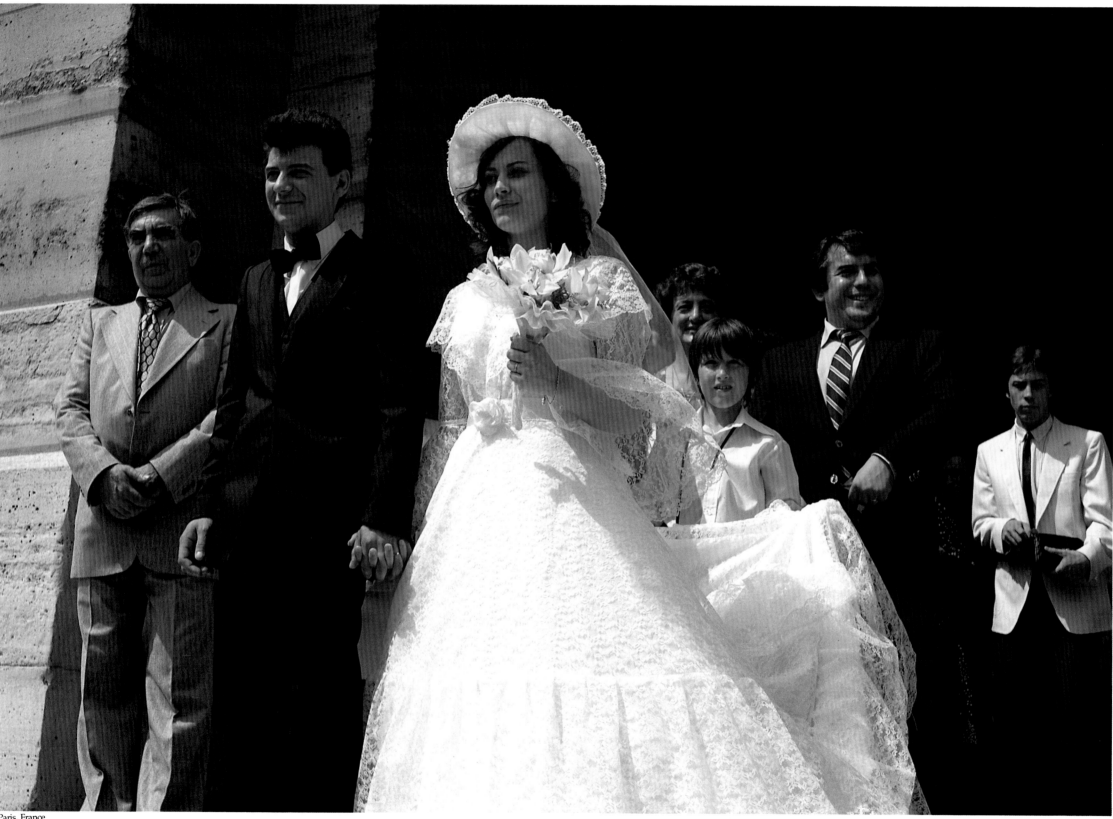

Paris, France

To him in whom love dwells, the whole world is but one family. —*Buddha* The human life cycle is the same all over the world. It is likely that a 70-year-old woman in Malaysia and a 70-year-old woman in Canada would have more in common than either of them would have in common with a 20-year-old woman in her own society. Each would have had the experience of getting married, learning to live with a man, setting up a home, having and raising children, nursing her family through illnesses, working in a field or shop, seeing her children safely grown and settled into work and families of their own, watching grandchildren grow and blossom, and experiencing the grief of loss as relatives and friends age and die. These are universal experiences; experience is the key word here, because a 20-year-old cannot really know about life's passages until they are experienced.

For many people, entry into adulthood is signaled by getting married. The couple takes on responsibility for each other, and they make a statement that they are willing to join together to "face the world" and to create their own ways of expressing their talents. Young adulthood is a time for ambition and creativity.

In middle life, there is consolidation; it is an age of power and responsibility. As Erik Erikson says, "Mature man needs to be needed, and maturity is guided by the nature of that which must be cared for."

In old age, the power of experience can teach the young about human dignity and love, and about the meaning of human striving.

Here, Nagashima's photographs dramatically show the samenesses that the world's people share. Although marriage, family life, work, relaxation, and celebration take many specific forms in different parts of the world, the substance is the same. The forms are simply expressions of how we live out a balance between realizing our abilities and wants, on the one hand, and forging links with our fellow earthlings, on the other. The great English poet John Donne said, "No man is an island, entire of itself." We share the earth, and there is a universality about how we find our ways through our lives.

The work that we do does not simply define us or provide a livelihood. The artist Marc Chagall said, "Work isn't to make money; you work to justify life." Honorable work contributes to the world, whether we are aware of making a difference or not. Work means taking one's part, "pulling one's load." And honest work is not rank-ordered; working with one's head is no more honorable than tilling the soil or operating a machine. It is not our burden but our opportunity to take on the responsibility of work. Nagashima's work shows work in many of its guises.

In a sense, each of us lives out an adventure as we pass through young adulthood and our middle years. We write our life scripts as we go along, guided by the teachings that we were exposed to as children. It is up to each of us to grow into responsibility and to find our own ways of developing our potential. Families give us support, co-workers bring out our untapped abilities, and our friends keep us young.

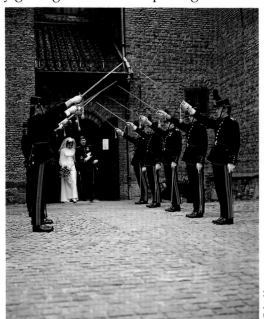

Oslo, Norway

NO MAN IS AN ISLAND

THE JOY OF FAMILY

The family unit is the foundation on which all cultures are built. Every social experiment that has attempted to transfer the allegiances of blood to a state or a leader or an organization has ultimately failed to weaken the natural bondedness of the family connection. The family situations captured here by Nagashima sharply illustrate the power of the family experience.

There may be troubles within a family; there usually are, in fact. Some family members find the ties too binding, some feel less cherished than others, some vie for power within the clan. A Japanese proverb says, "It is easier to rule a kingdom than to regulate a family." But when challenges to a family come from outside, family members cleave to each other, affirming that they need each other to make the world work.

A person has to prove himself to outsiders, but, as T. S. Eliot said, the love within a family is "not looked at." Your family loves you not for what you are or for what you do, but just because you are.

A truly complete relationship, by its existence, contributes to the entire world.
—WERNER ERHARD

Niigata, Japan

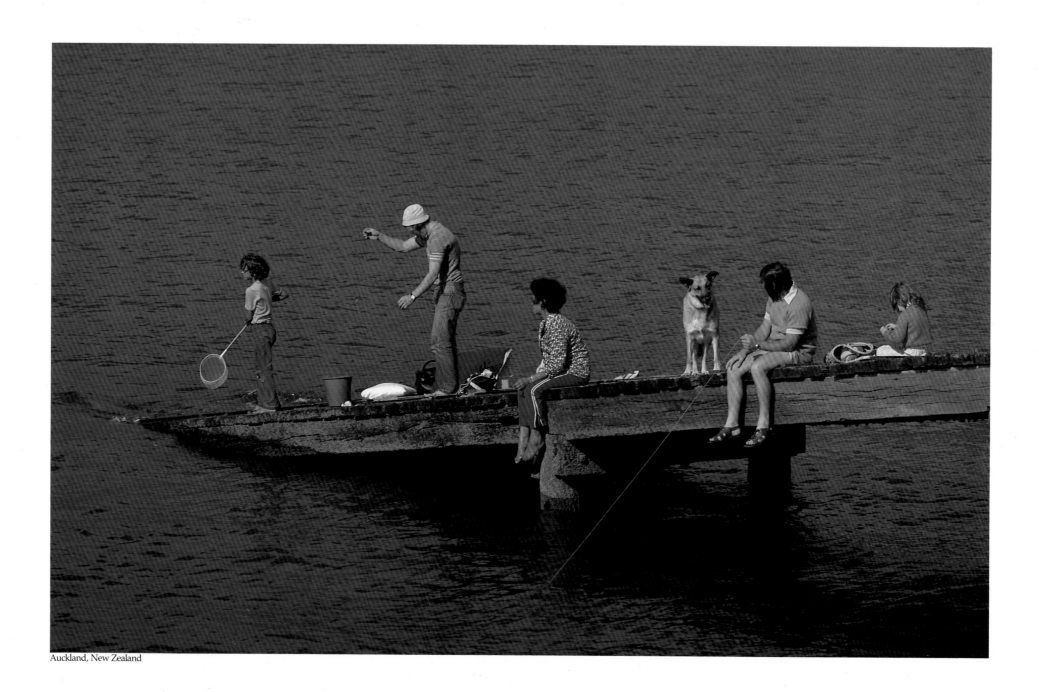

Auckland, New Zealand

We can stand on a slope to the deep, and not fear it.
We may sit in a bliss of solitude, and not be alone.
Quietly, the line of family connects us always.

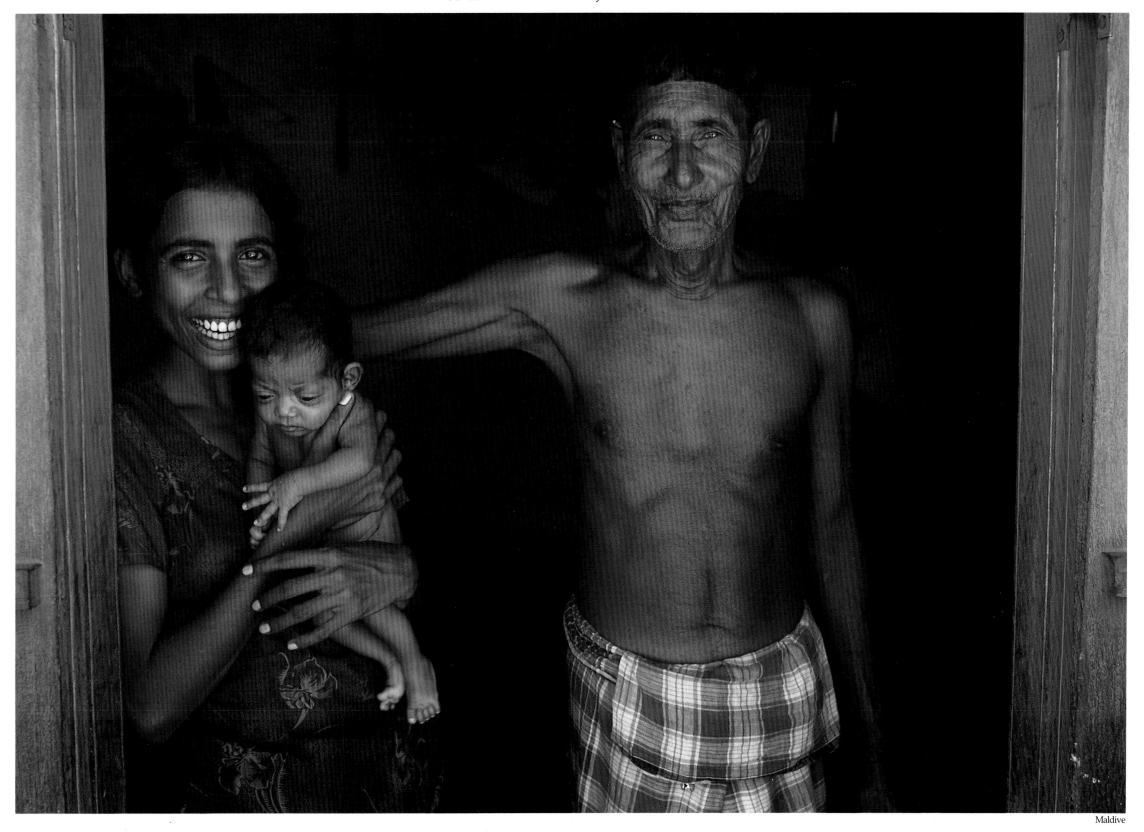

Maldive

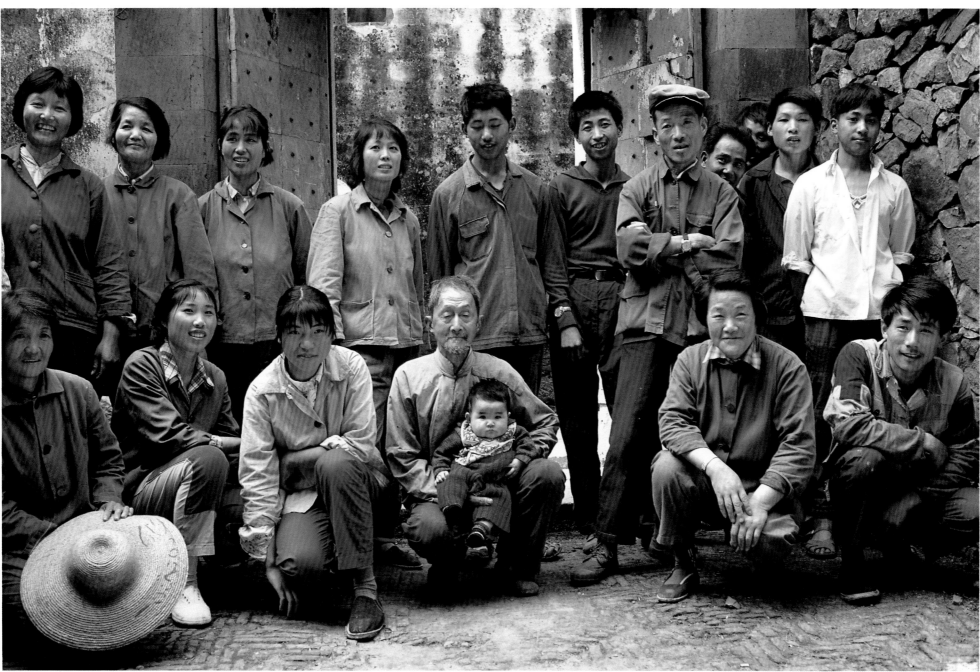

China

Four generations of our family in our remote farm village bring the past and the future to one of those crossways in time that lace our globe about, layer on centuried layer, holding it together.

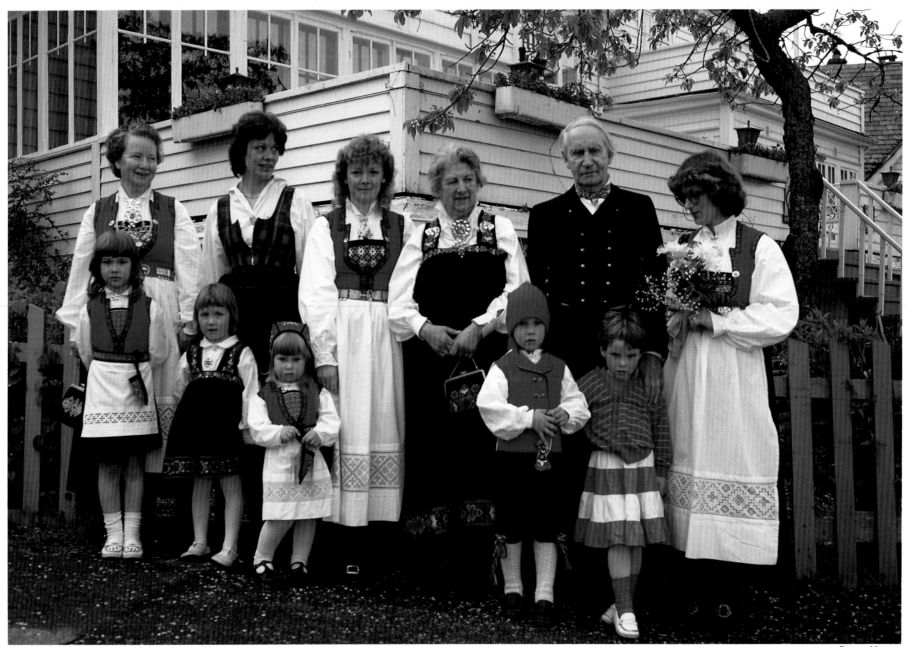

Bergen, Norway

THE FRUITS OF OUR LABOR

Work is a natural part of human life. We must work just to maintain the world as it is, and work a bit harder to make progress. Some individuals see their work as a burden, and they fight it. But for most people, work not only feeds their bodies, it sustains their spirit. Theodore Roosevelt said, "Far and away the best prize that life offers is the chance to work hard at work worth doing." Luckily, most work in the world is worth doing.

Honest work elicits our highest selves, helps us to continue the processes of growth set into motion in childhood, and puts back into the world more than we take from it for sustenance. Lower animals leave evidence of their existence; people leave evidence of their creation.

Business and political leaders need to understand that organizations cannot exist without attention to the people who work to make them run. Sensitivity to the needs of people and respect for their dignity not only affirms and strengthens the human bond between leaders and others, it also generates enthusiasm for participation, craftsmanship, and productivity.

The diversity of human occupations is so great that it is almost impossible to define work. Many people work in fields and waters to provide food. A fisherman might be a solitary angler like the one Nagashima photographed here, selling his day's small catch, or he might be a member of a large crew on a giant tuna seiner out of San Diego harbor. A person who works to provide fuel might be a petroleum engineer on a North Sea oil drilling platform or a young Egyptian girl who collects and sells sacks of camel dung. There are bakers of bread the world over. And everywhere women work, as they keep their families fed and cleansed and as comfortable as the circumstances will allow.

Nagashima was fascinated by workers in the seventy-eight countries he visited, and the photographs in this section show people at work in a wide variety of situations. What they seem to have in common is a quiet joy in being gainfully employed, contributing their skill to the maintenance of their family and their society, whether in the hustle-bustle of a stock exchange or on a market boat.

I have finally come to a simple philosophy of work. I enjoy what
I am doing and do the best I can. That is enough.
—MARIA SCHELL

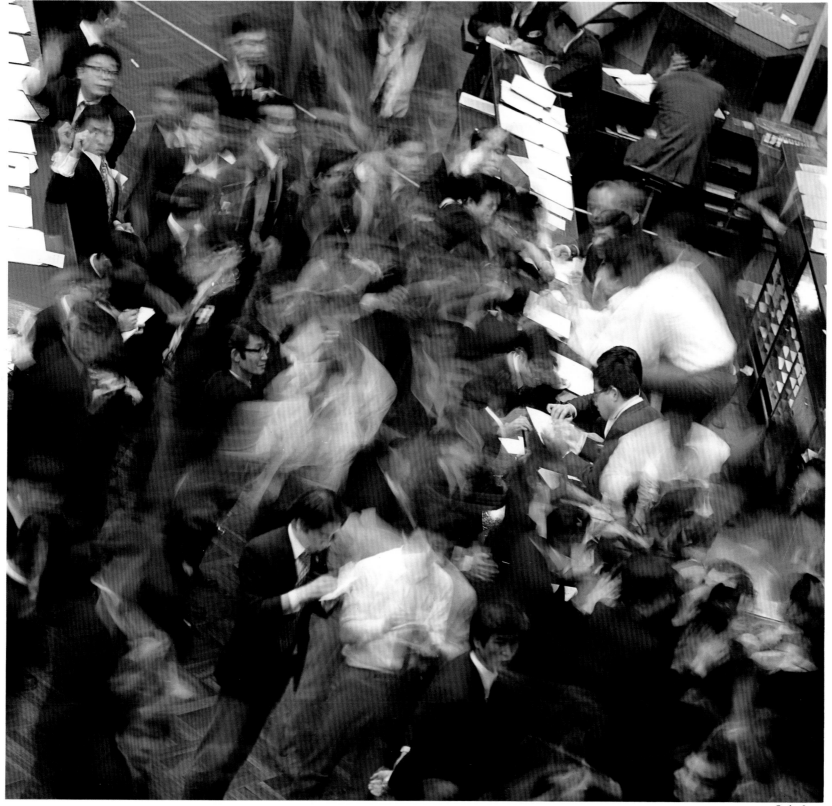

Osaka, Japan

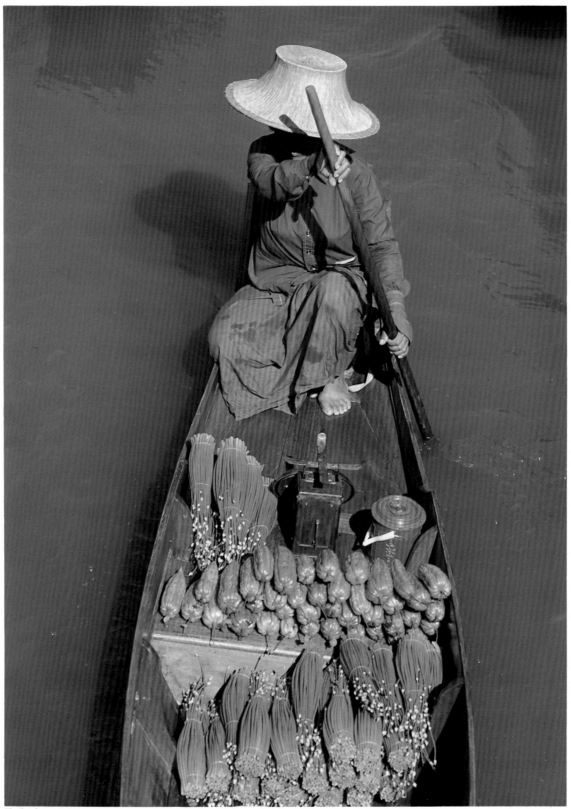

Thailand

Clean, crisp, offered whole,
for your eye, and then your tongue,
food I grew with care.

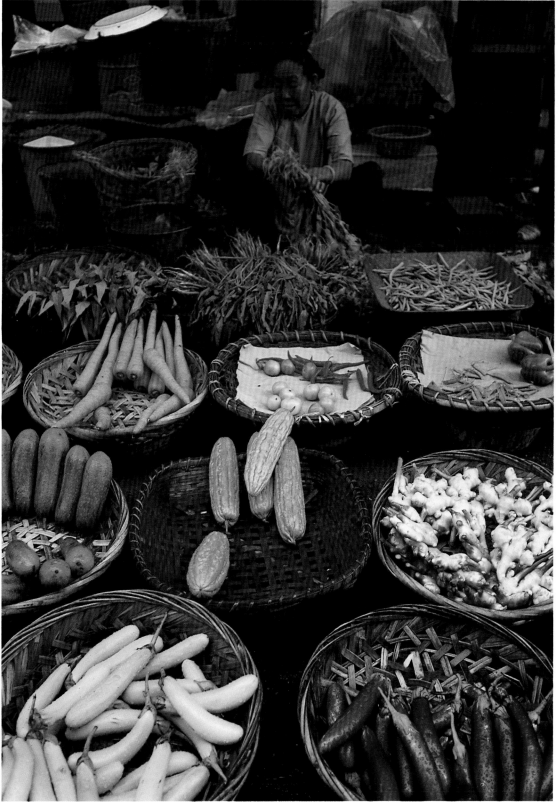

Penang Island, Malaysia

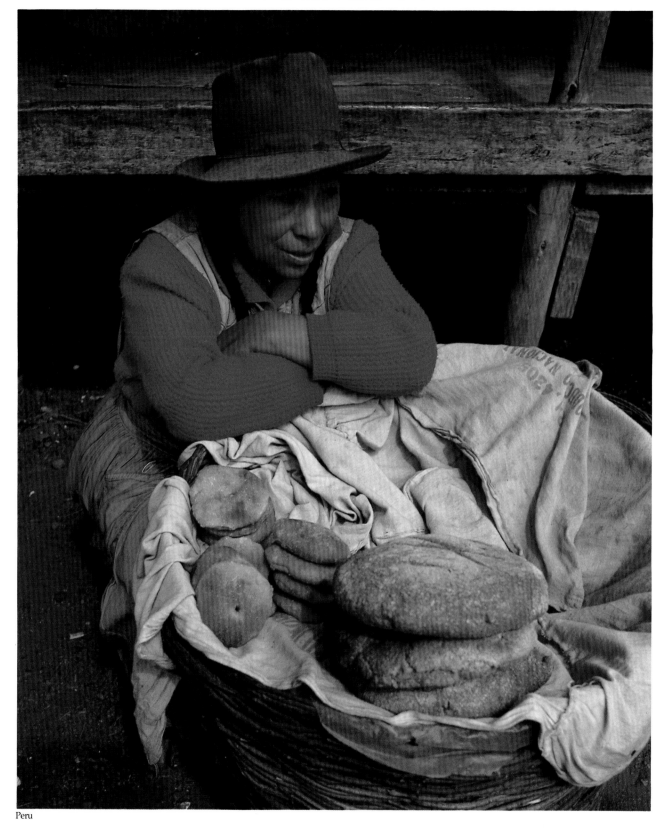

Peru

Indonesia

Where we put our hand,
life creates what sustains it—
gifts of bread and rice.

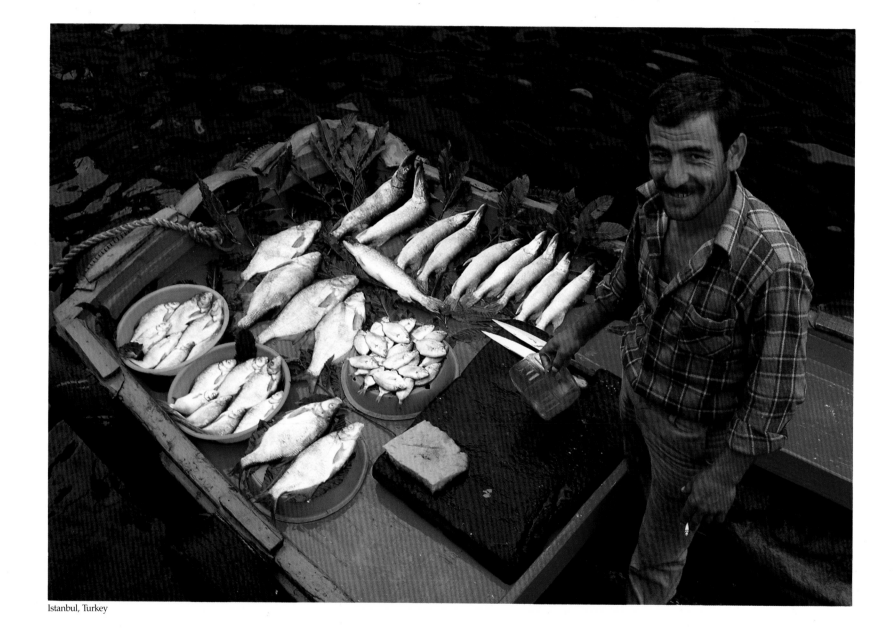

Istanbul, Turkey

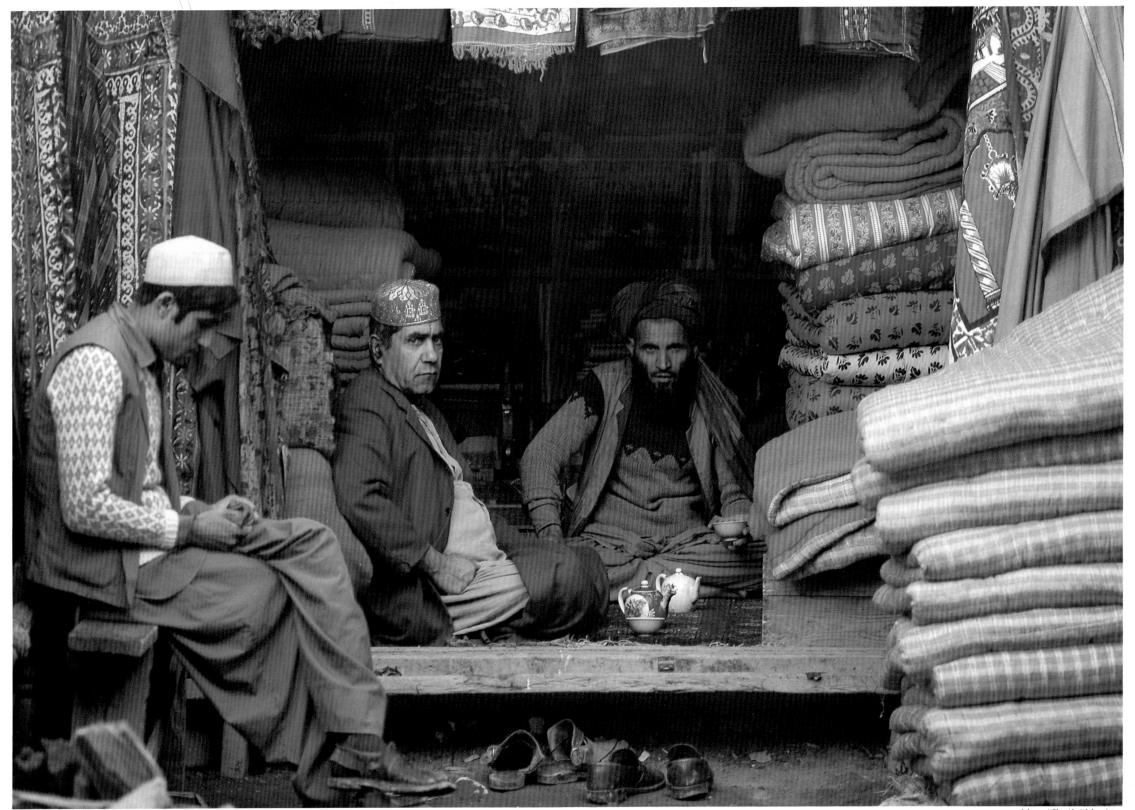

Mazar-i Sharif, Afghanistan

Do you want to see
the pattern of the whole piece?
Come bargain with us.

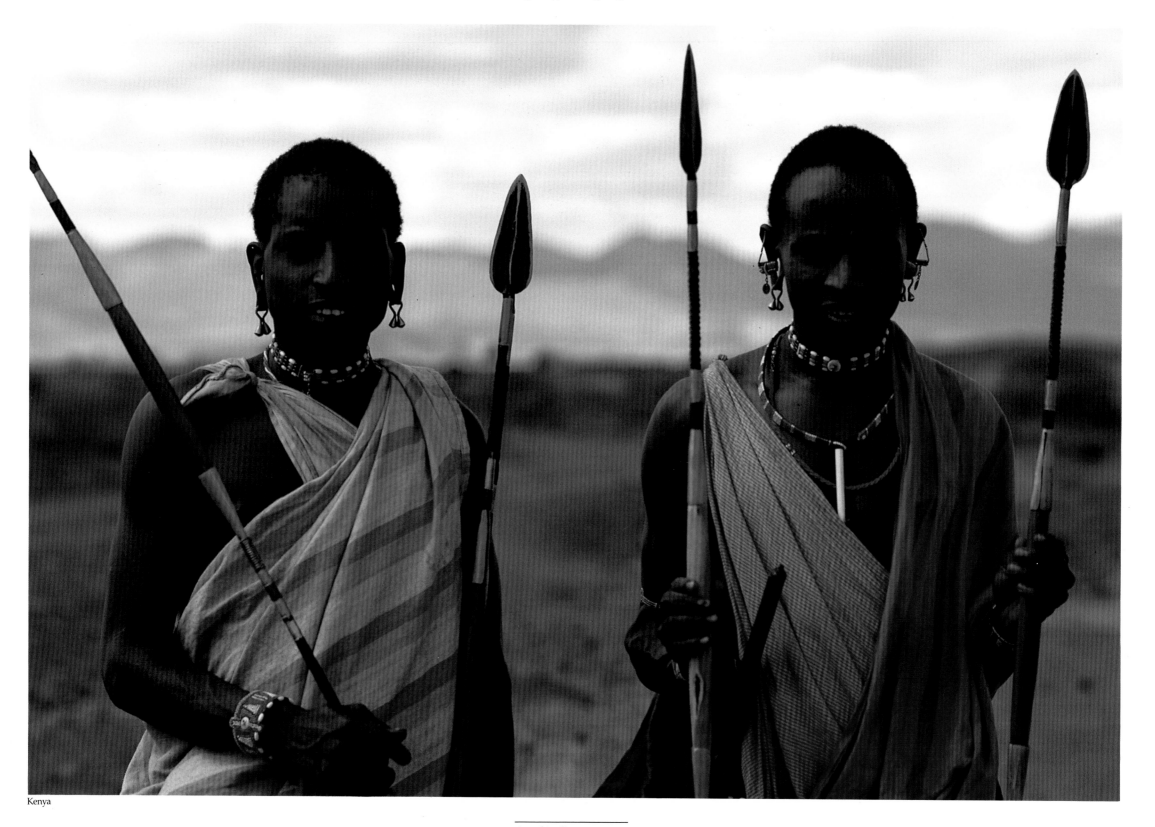

Kenya

A tool is alive;
it has its own signature,
as its user does.

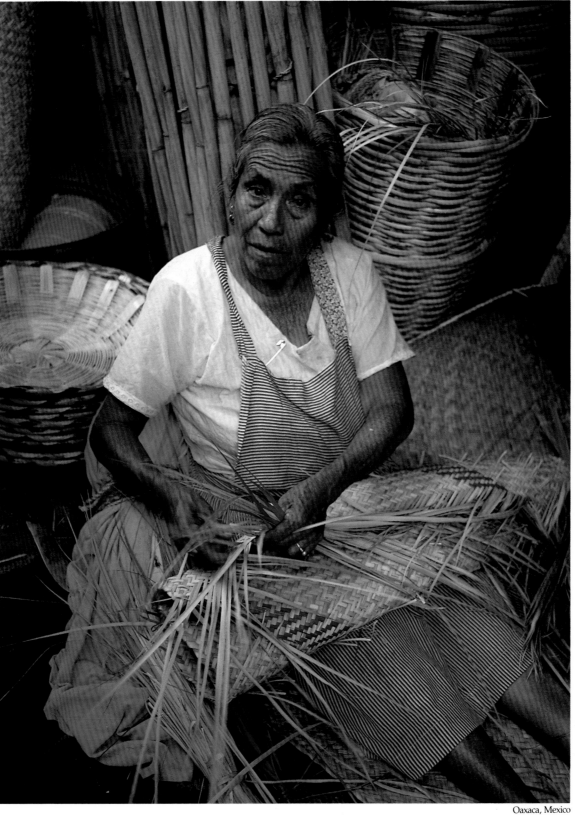

Oaxaca, Mexico

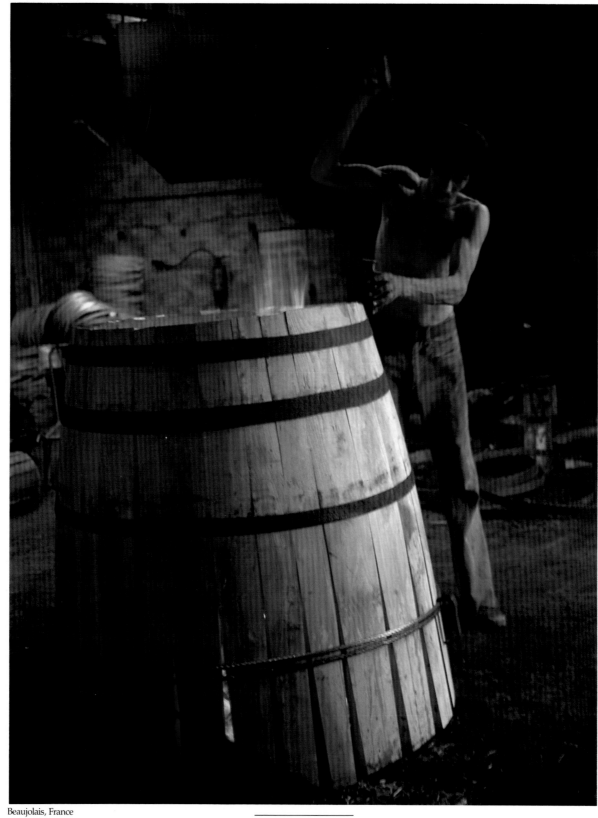

Beaujolais, France

Volcano in wood
obedient to my hand
to hold my treasure.

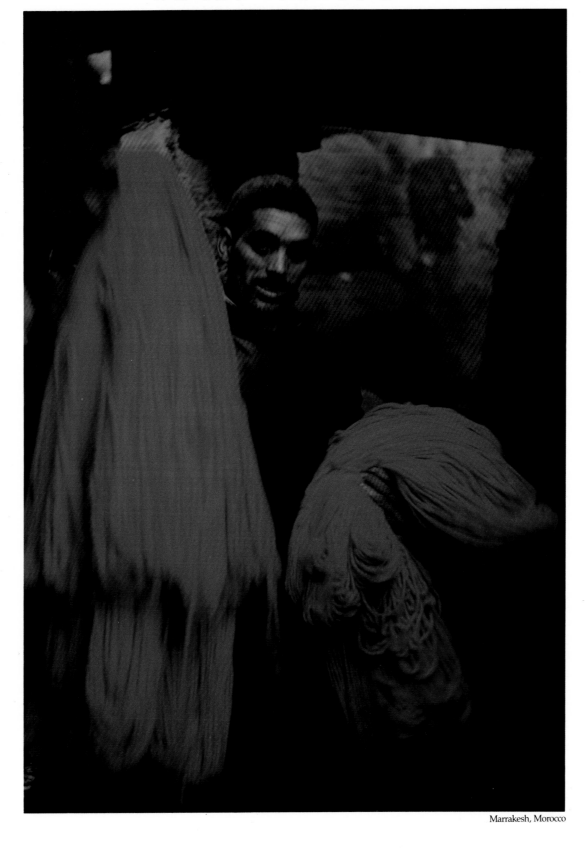

Marrakesh, Morocco

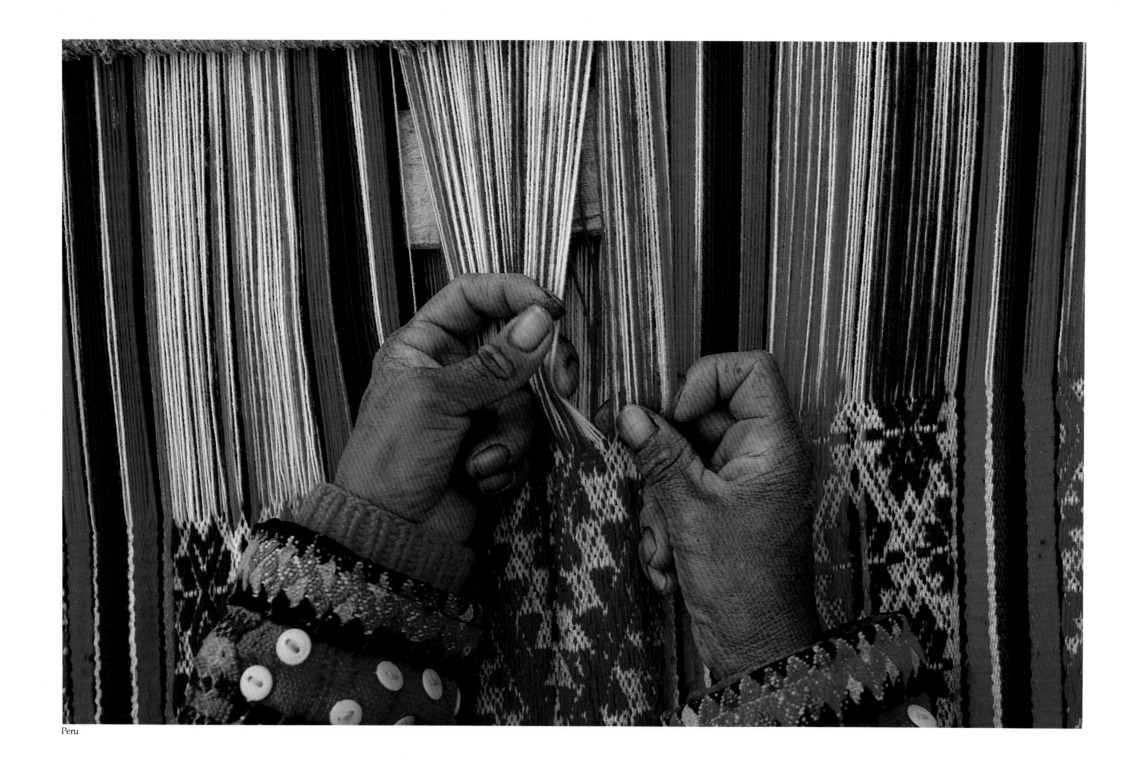

Peru

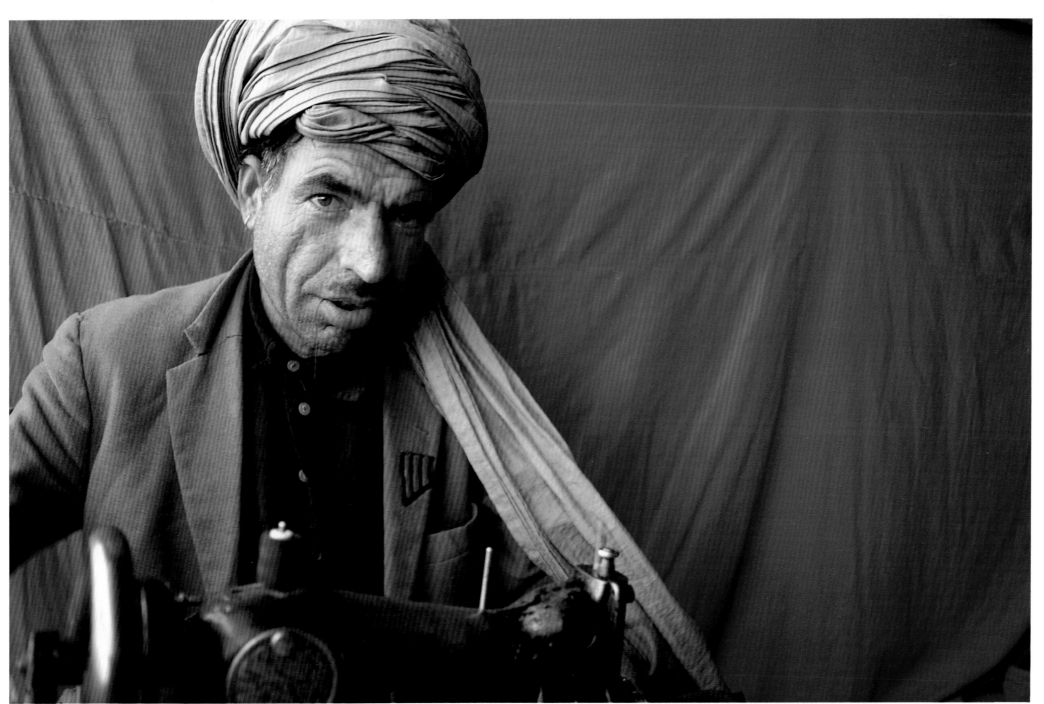

Queta, Pakistan

Fabrics could wrap us
without beauty; not enough.
Our hands give them shape.

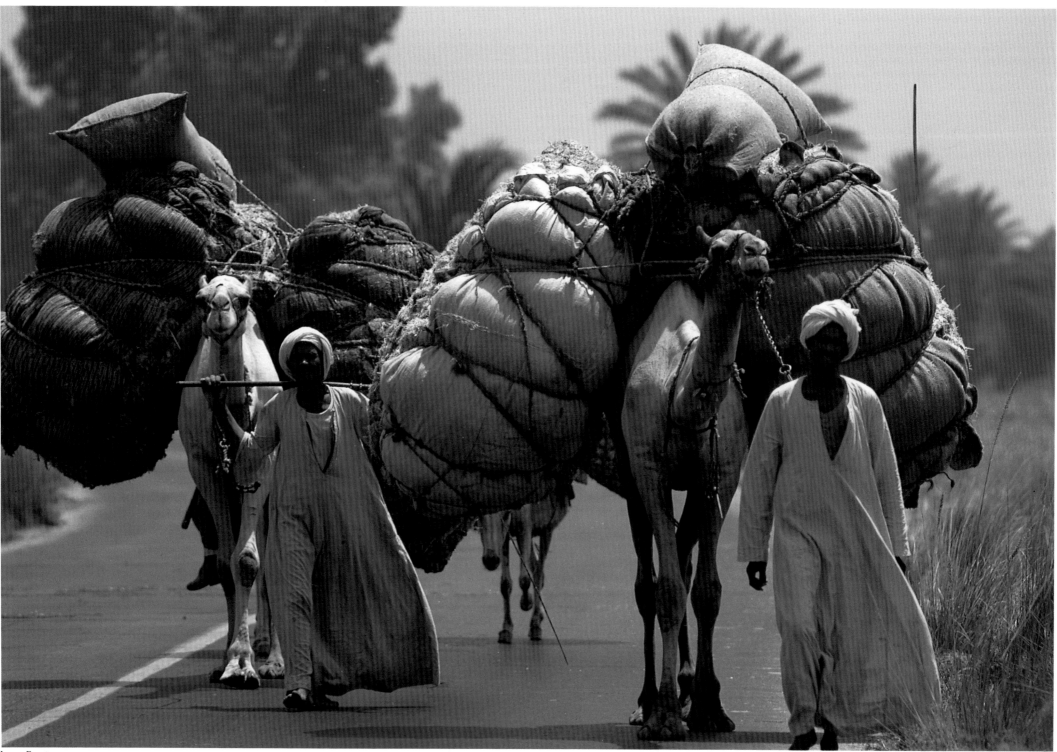

Luxor, Egypt

Ships of the desert
haul cotton to the city,
our partners at work.

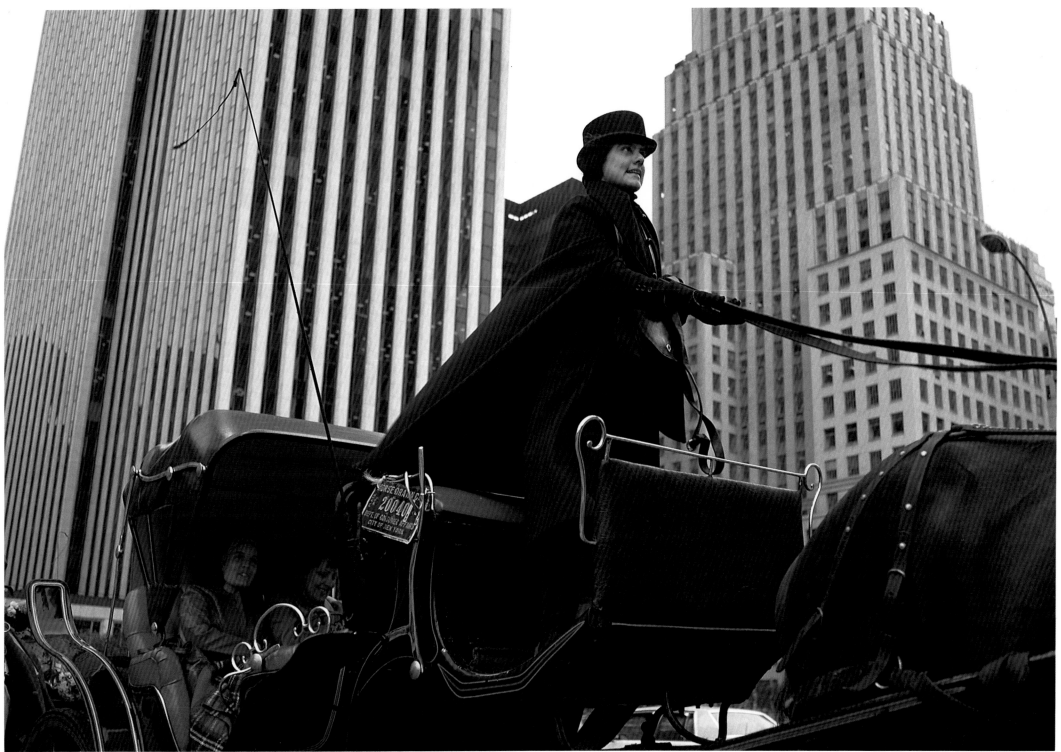

New York City, U.S.A.

Taxi of the past,
clopping through concrete and glass,
our partner at play.

THE GIFT OF LEISURE

Away from work, adults find endless ways to occupy themselves, and Nagashima caught them at all sorts of leisure activities. Everywhere in the world people take time out to relax, to be with friends, to make art or to appreciate it, to celebrate.

Paul Goodman remarked that "a fine sense of value" would be required for the fruitful use of extended leisure if people were ever faced with more leisure time than working time. The photographs in this section suggest that most people would have no trouble finding valuable ways to spend their time off. And those ways seem not to differ in essence from country to country.

People get together, sometimes just to share a beautiful sunset, sometimes to celebrate one of life's passages—a birthday, a name day, an anniversary. We gather together to commemorate past events, to give thanks, to welcome in the new year, or simply to have fun. Sometimes we even forget the original purpose of the ceremony, since the activity itself is so engrossing.

Many are lucky enough to express themselves through their work; for those whose work is routine or burdensome, non-work activities are the vehicle of self-expression. Leisure time allows people to rise above being beasts of burden, to discover who they are, and to enjoy each other.

It is in his leisure that a man really lives; it is from his leisure that he constructs the true fabric of self.

—AGNES REPPLIER

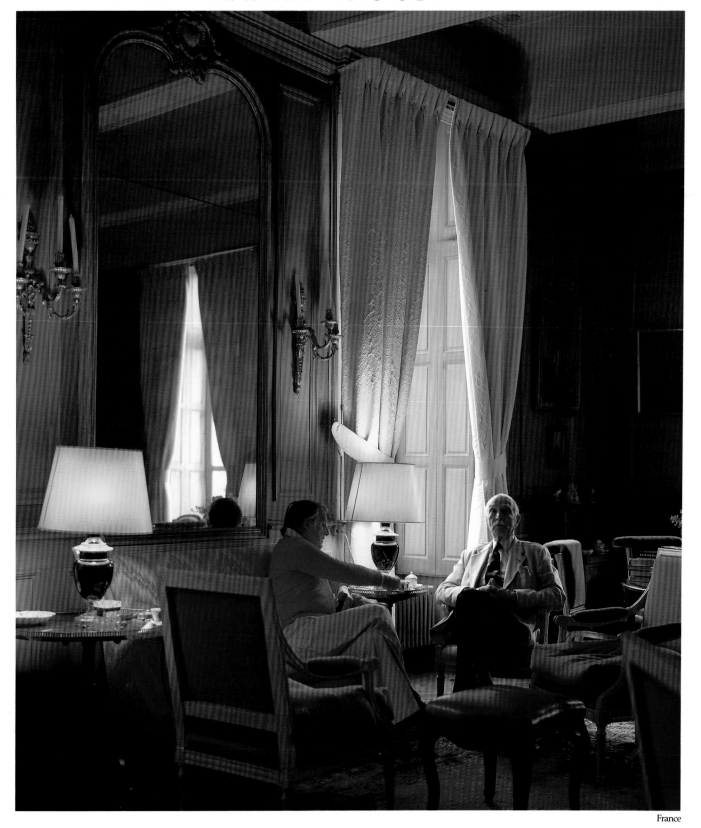

France

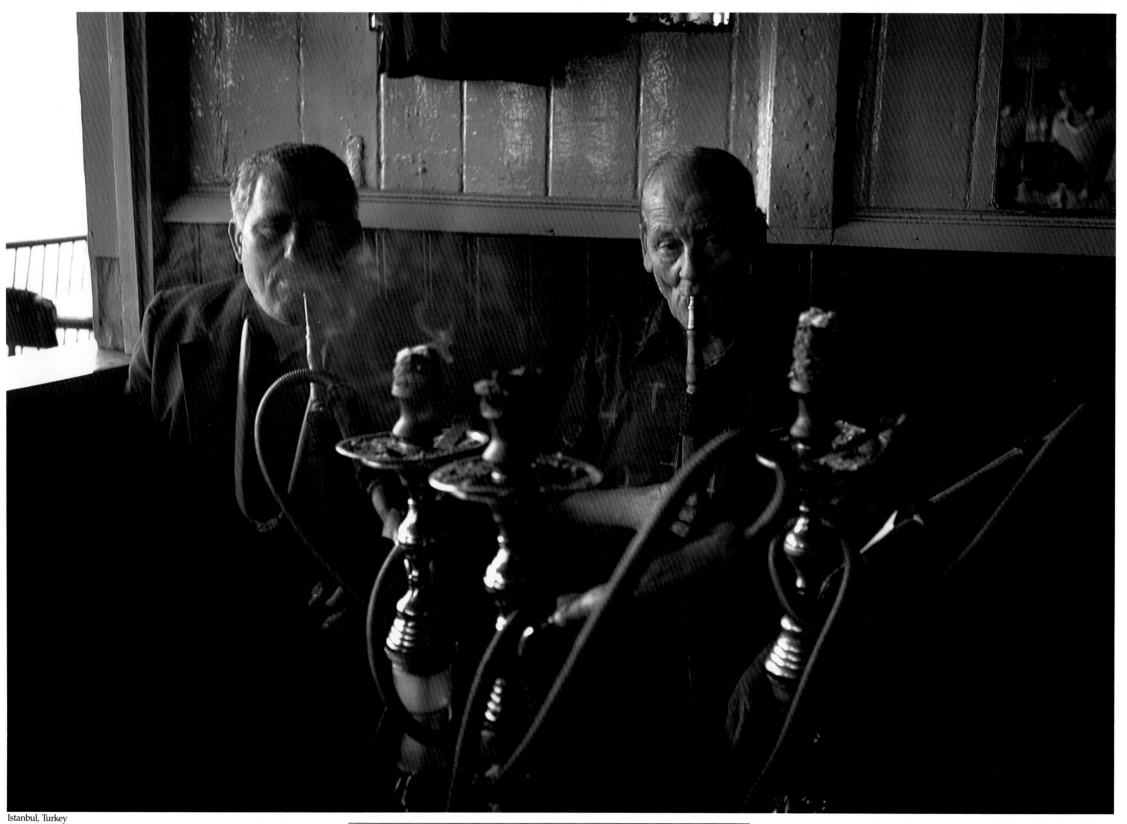

Istanbul, Turkey

Our days expand and contract with what we put in. We fill them with work; fill them again with rest and dreaming; again with companionship; again with celebration; and again with reflection. We use time—silent, visible, elusive, elastic, almighty Time —to create the patterns that connect us.

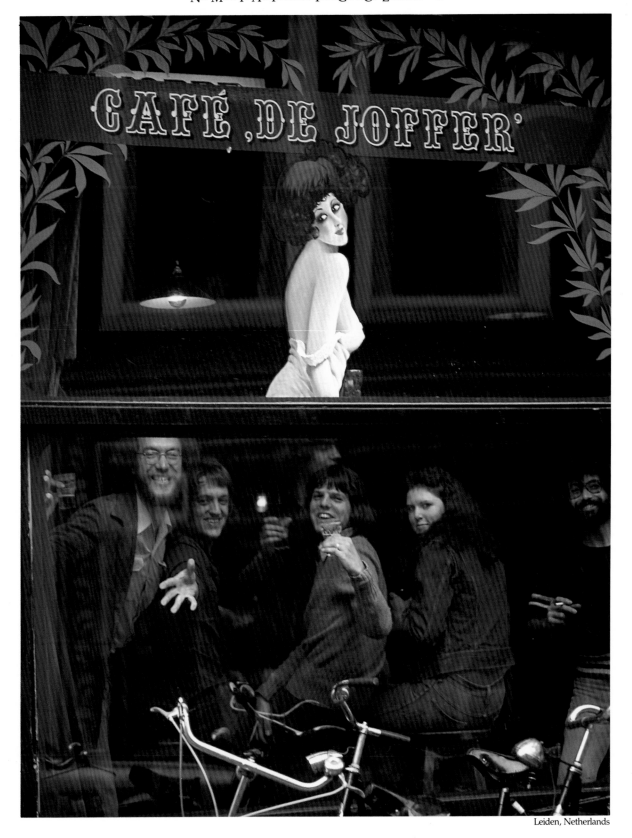

Leiden, Netherlands

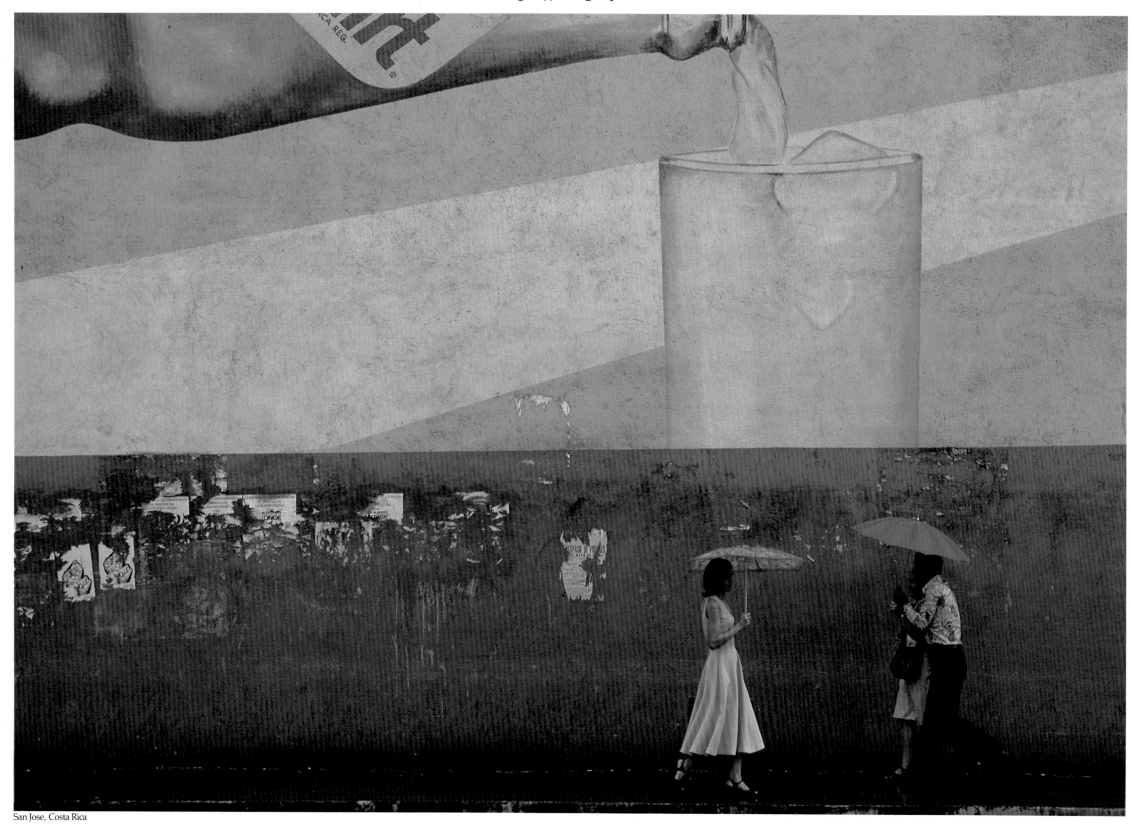

San Jose, Costa Rica

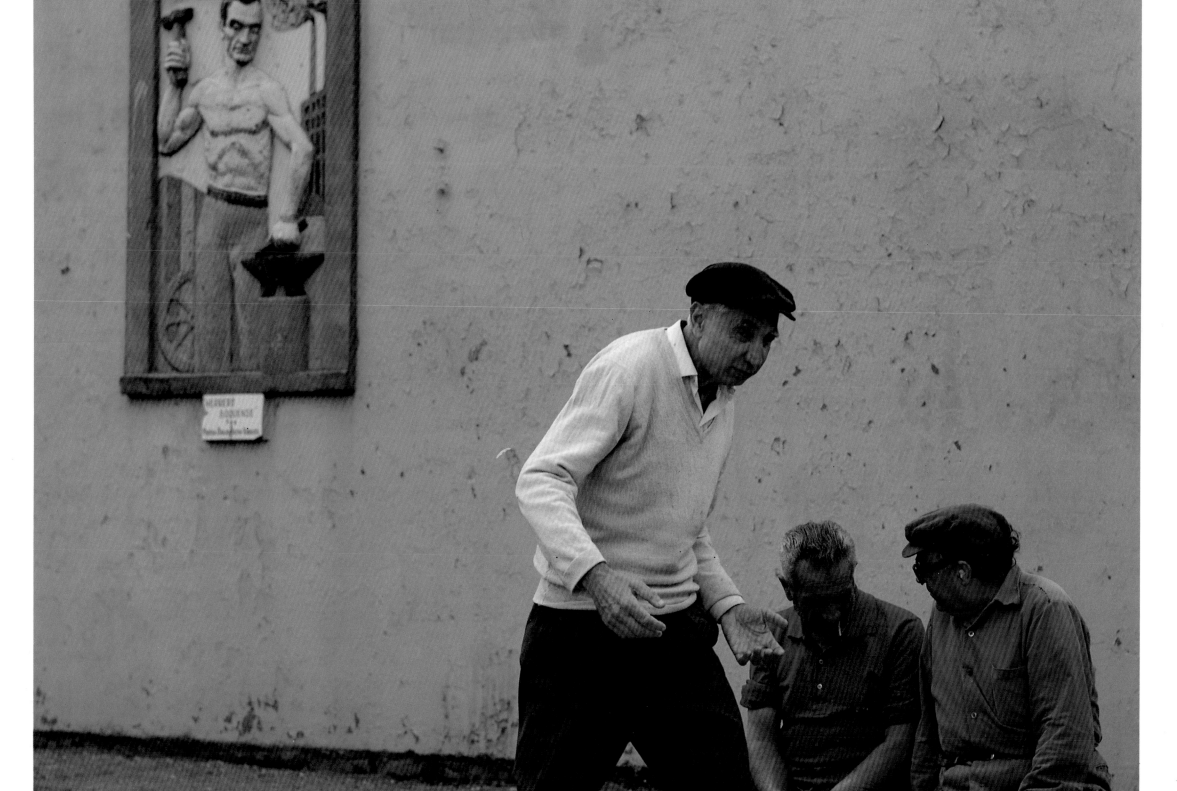

Buenos Aires, Argentina

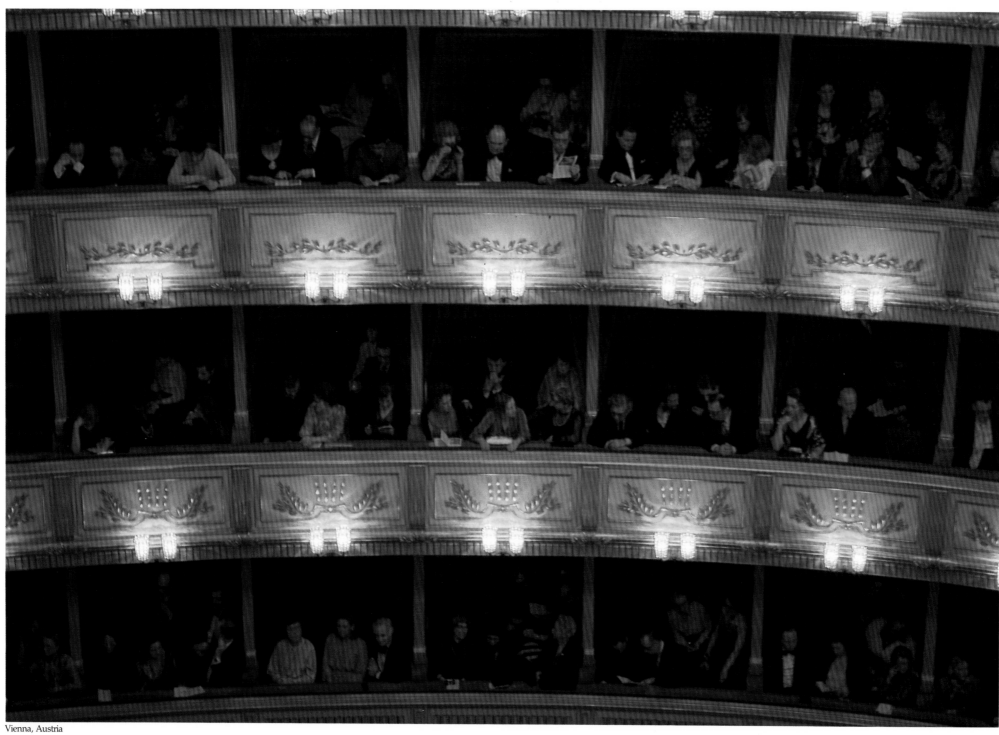

Vienna, Austria

There is a music—for the ear, for the eye, for the spirit—that increases us where we gather
amid harmony, order, and proportion.

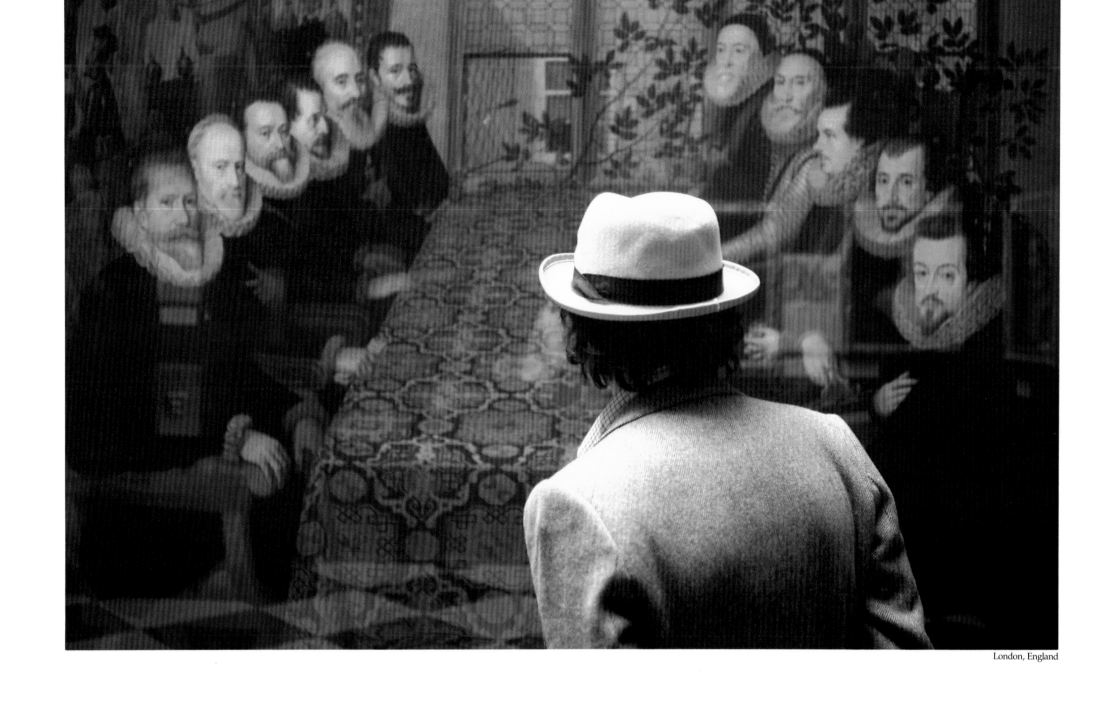

London, England

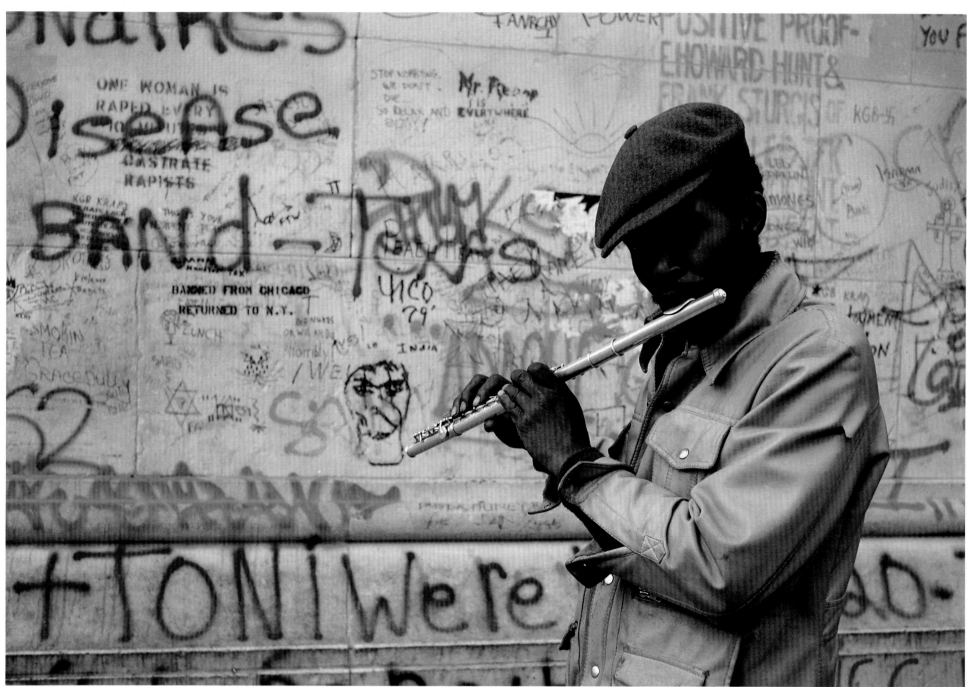

New York City, U.S.A.

I can pause to speak, and hear, in any voice I choose. In some moments I hear it so deeply that it is not heard at all; then, while the voice lasts, I am the voice.

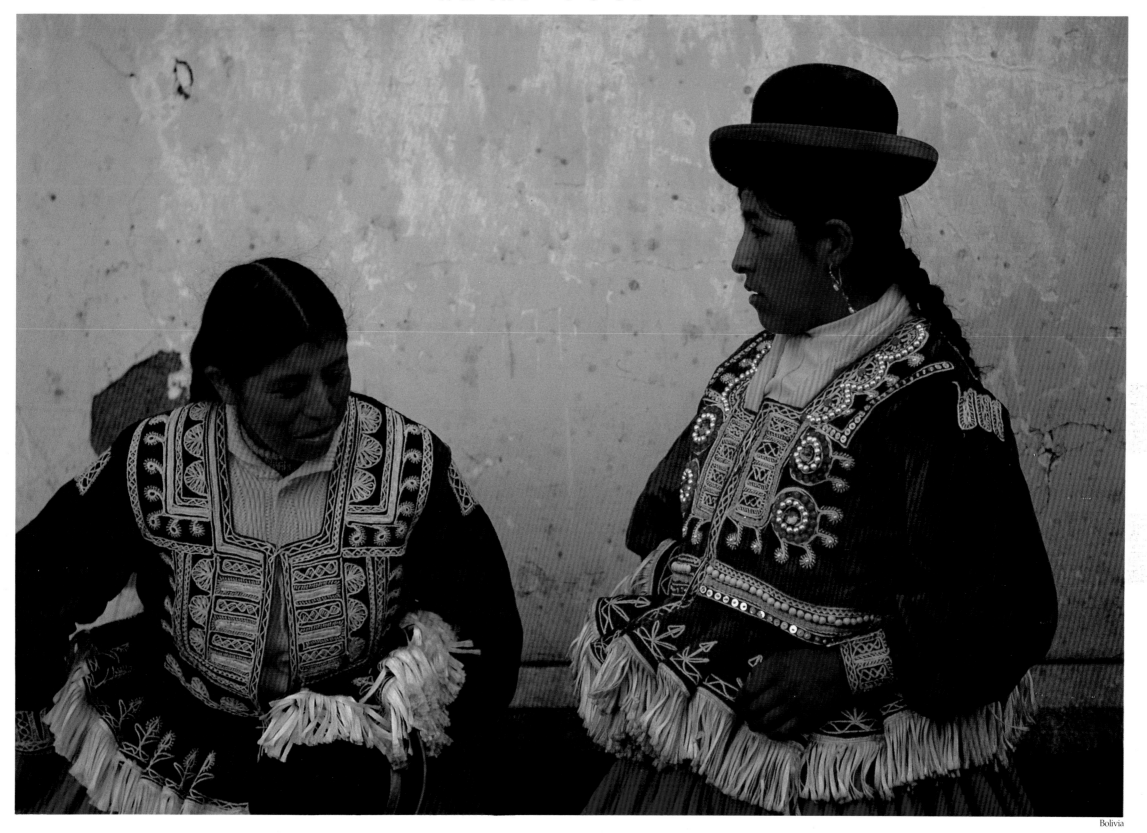

Bolivia

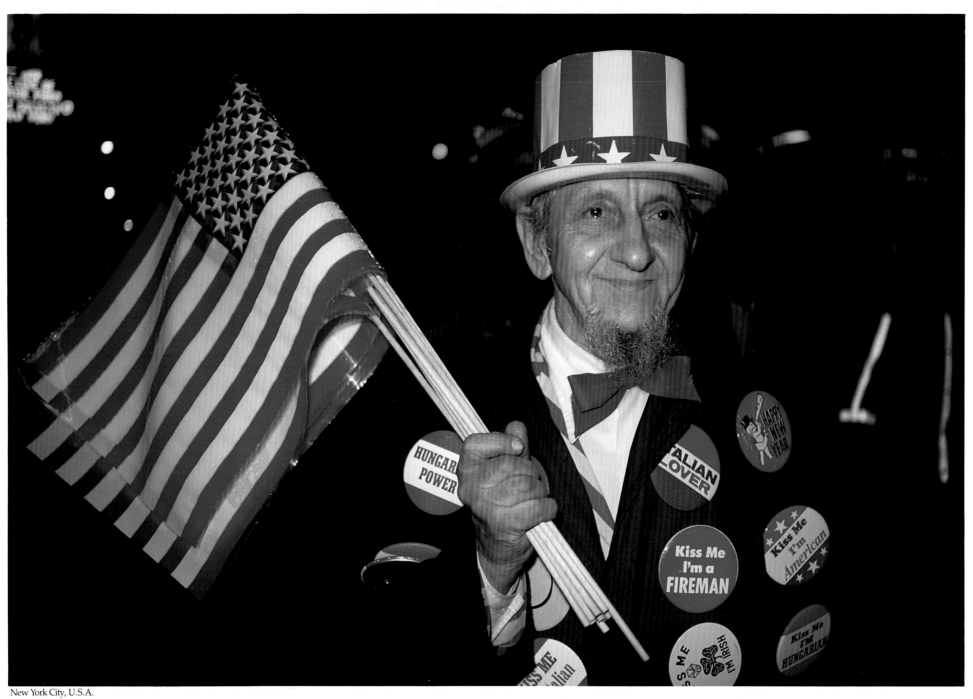

New York City, U.S.A.

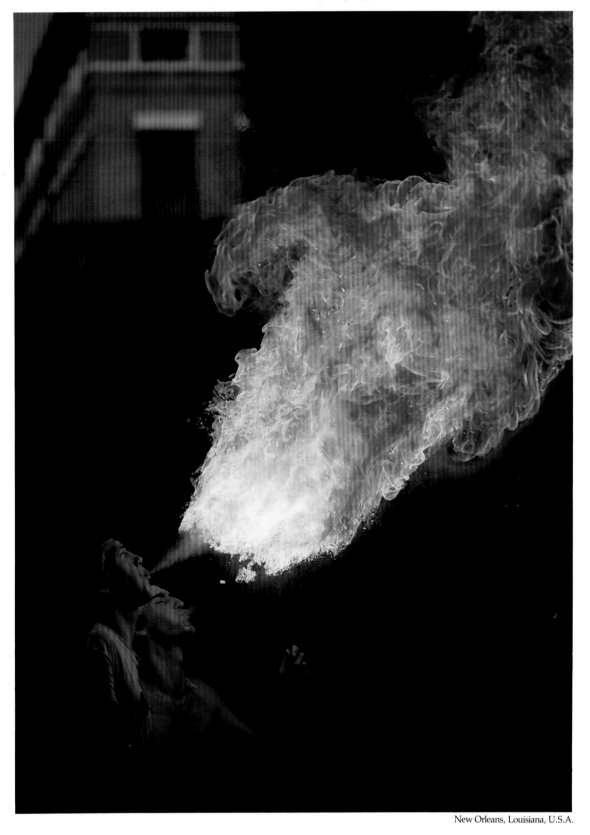

New Orleans, Louisiana, U.S.A.

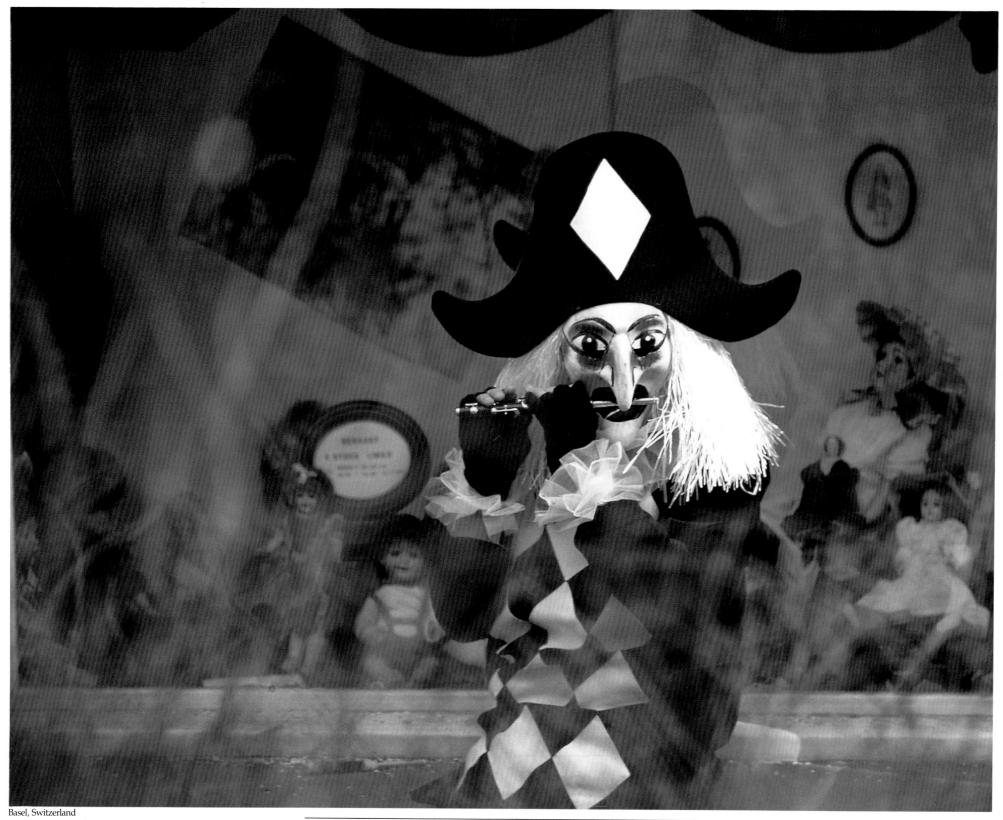

Basel, Switzerland

Some of us old youngsters—behind the mask we wear every day but this one—for disguises that will let us speak, and hear, and uncover the heart.

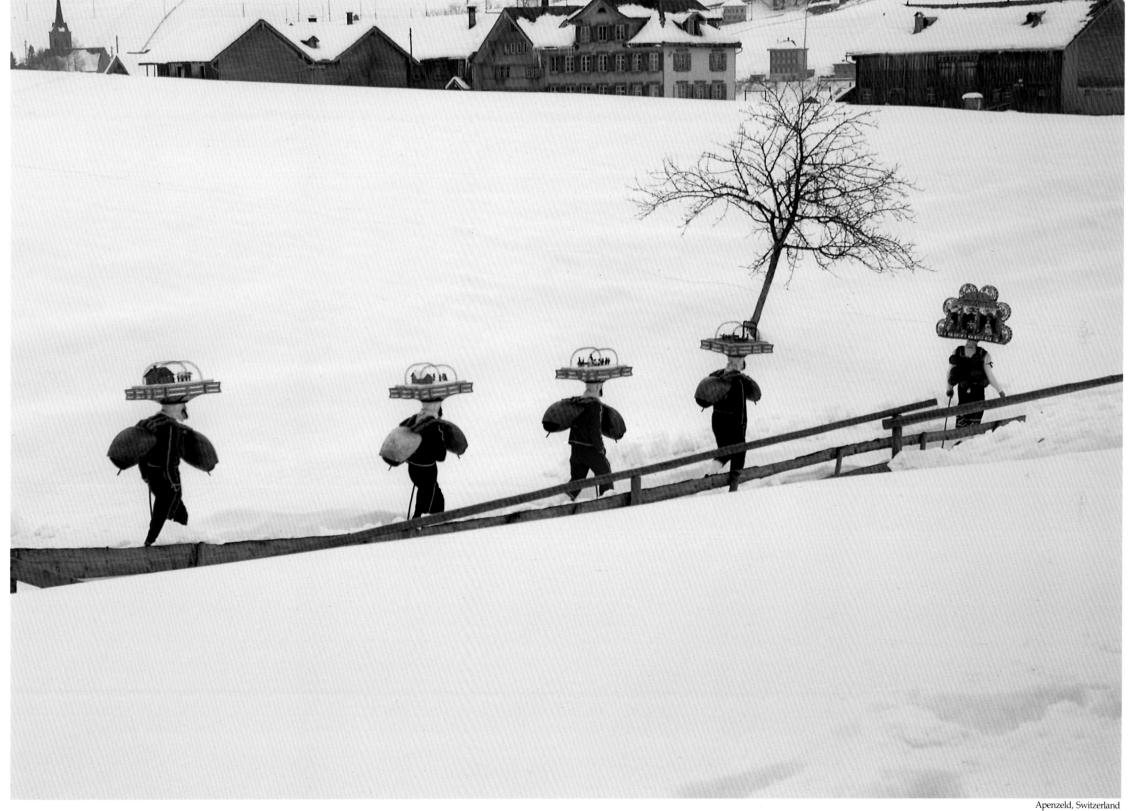

Apenzeld, Switzerland

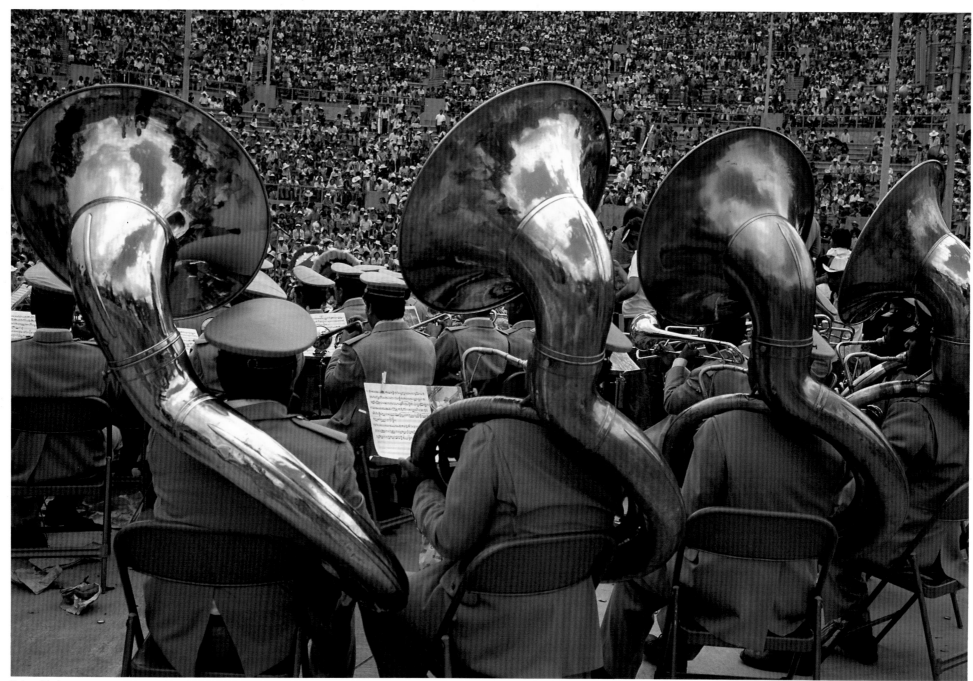

Oaxaca, Mexico

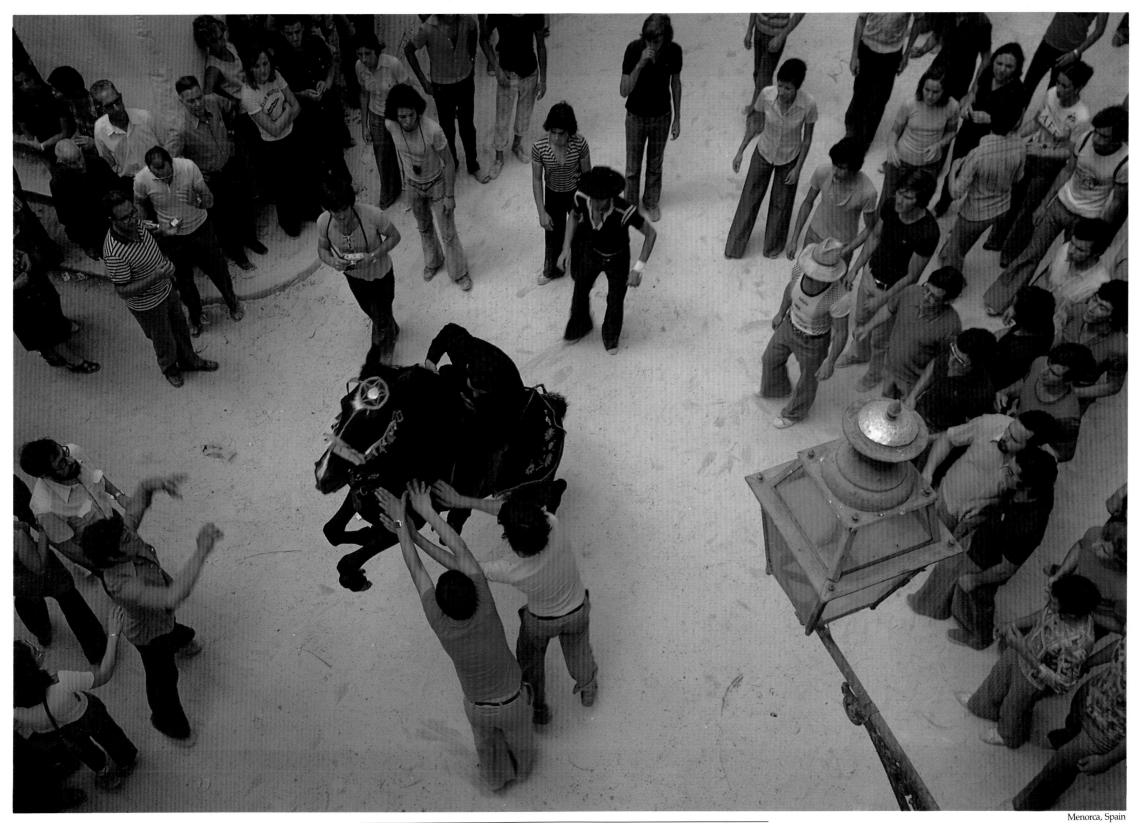

Menorca, Spain

Festivals rouse us to come out in trim array. You prance your horse through town and,
to share your price and feel our wonder, stop to let us touch.

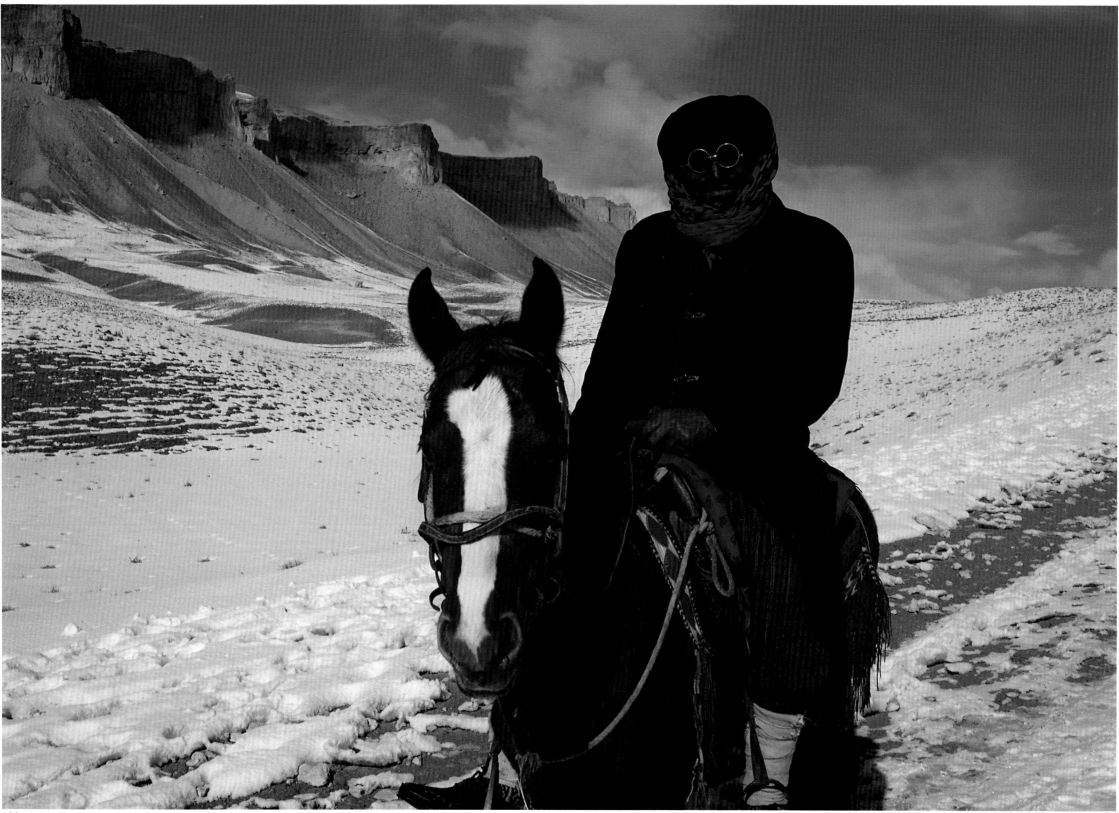

Afghanistan

THE POWER TO ANIMATE ALL OF LIFE'S SEASONS IS A POWER THAT RESIDES WITHIN US. —*Gail Sheehy* The human experience—birth, growing, learning, work, celebration, religion, renewal—is basically alike for everyone. As each of us searches for meaning and integrity in our existence, we contribute to the growth of people everywhere. As Martin Luther King, Jr., put it, "The quality, not the longevity, of one's life is what is important." This final section celebrates and reflects on the whole of the power of the human experience. We see people communicating with each other, working in self-expressive ways, relaxing, meditating, communing with nature, and worshipping. Finally, we see that life goes on. An individual life has limits, but the human experience is continuous, through its generations and its creativity.

The examined life is indeed worth living. As John Gardner says, "Life is an endless process of self-discovery." People at all stages of life are included in this final section, shown as they engage in actions that express their individual quests. We all find our own ways to search, along our journey, and to remain meaningfully connected to the earth and to its inhabitants. A man stands alone at oceanside. A sidewalk artist draws a madonna for the enjoyment of his public. A child is born.

We cling to life tenaciously—sometimes even at great sacrifice. In a way, life is what we make it. We can choose to perceive it as burdensome, or we can see it as a celebration of the divinity that is in each of us. Death is a part of every life—death of parents or friends and, inevitably, one's own end. The poet e.e. cummings used a closing parenthesis as a metaphor for death. Birth is the opening parenthesis, and the two enclose, for all of us, a tale including adventure and romance, joy and grief, upset and satisfaction, and sometimes a miracle.

One of the lessons in *A Course in Miracles* is "Teach only love, for that is what you are." One of the ways the people of the world carry out that charge is by loving life itself. The pictures in this section show life lived with caring and awareness.

Portugal

THE HUMAN EXPERIENCE

SOLITUDE AND RENEWAL

The number of people on the planet is increasing at an alarming rate. We are becoming crowded into larger and larger cities as our work becomes more complex. No wonder, then, that we find a kind of compensatory ballast in solitude. We seek out quiet, reflective times to renew ourselves. Helen Hayes said it well: "We live in a very tense society. We are pulled apart . . . and we all need to learn how to pull ourselves together. . . . I think that at least part of the answer lies in solitude." Sometimes, just getting away from the fast pace and the crowd with a loved one is enough. Nagashima's photographs in this section catch people in such quiet moments, connecting and communicating without words.

Self-renewal almost compels self-reflection. In order to "find" ourselves we must stop the world that we have created and take stock of our creation. Being outside helps, being quiet helps, and listening within helps. Indira Gandhi points out the discipline that it takes: "You must learn to be still in the midst of activity and to be vibrantly alive in repose."

Sometimes we find ourselves alone when we have not chosen solitude. Then being alone can be frightening. Han Suyin, a Chinese physician who combines writing and conducting her own research, observes: "All humans are frightened of their own solitude. Yet only in solitude can man learn to know himself, learn to handle his own eternity of aloneness. And love from one being to another can only be that two solitudes come nearer, recognize and protect and comfort each other."

The happiest of all lives is a busy solitude.
—VOLTAIRE

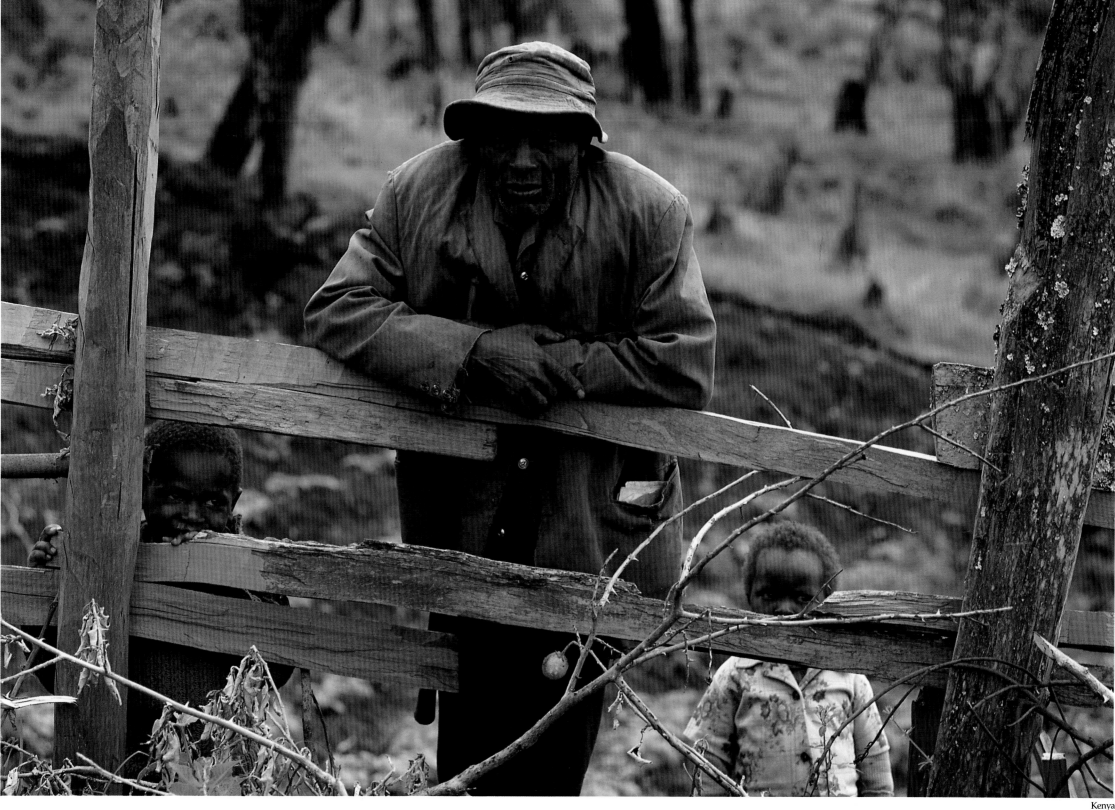

Kenya

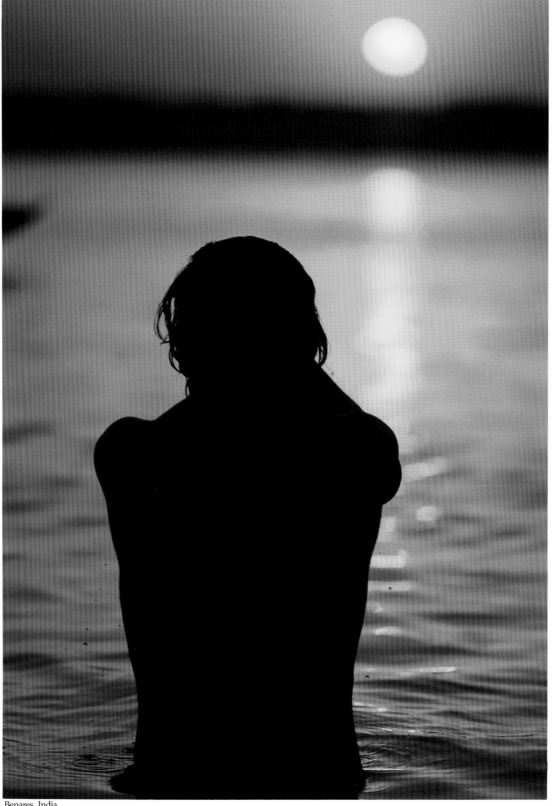

Benares, India

The goal ever recedes from us. . . . Salvation lies in the effort, not in the attainment.
Full effort is full victory.

 —MOHANDAS K. GANDHI

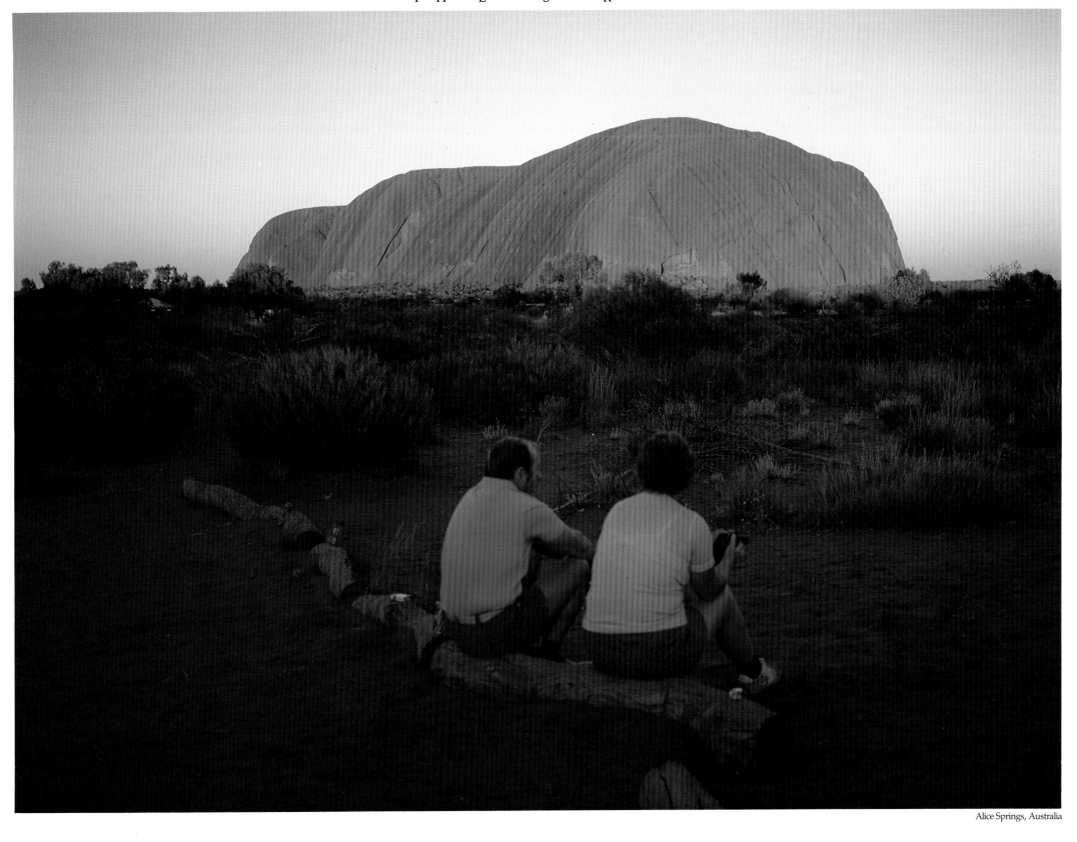

Alice Springs, Australia

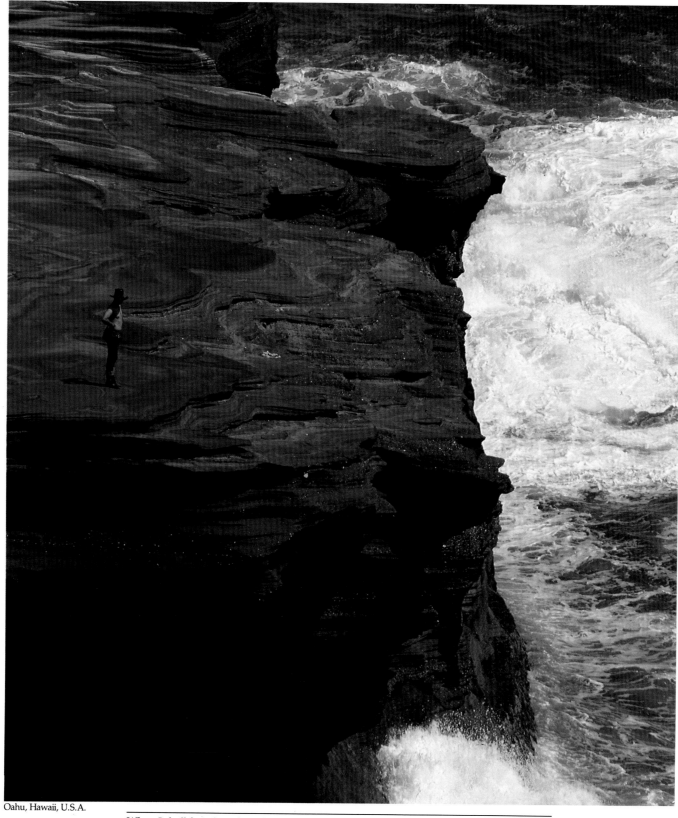

Oahu, Hawaii, U.S.A.

When I shall face the celestial tribunal, I shall not be asked why I was not Abraham, Jacob, or Moses. I shall be asked why I was not Zusia.
—REB ZUSIA OF OMPOL

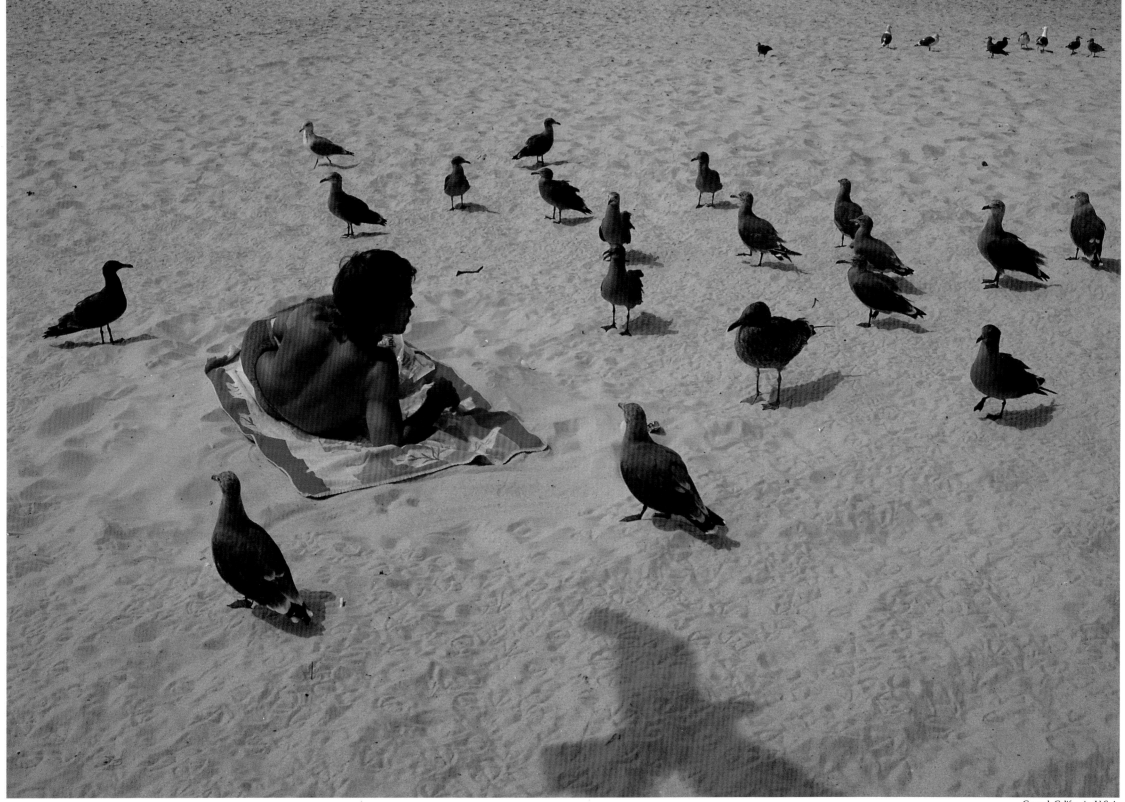

Carmel, California, U.S.A.

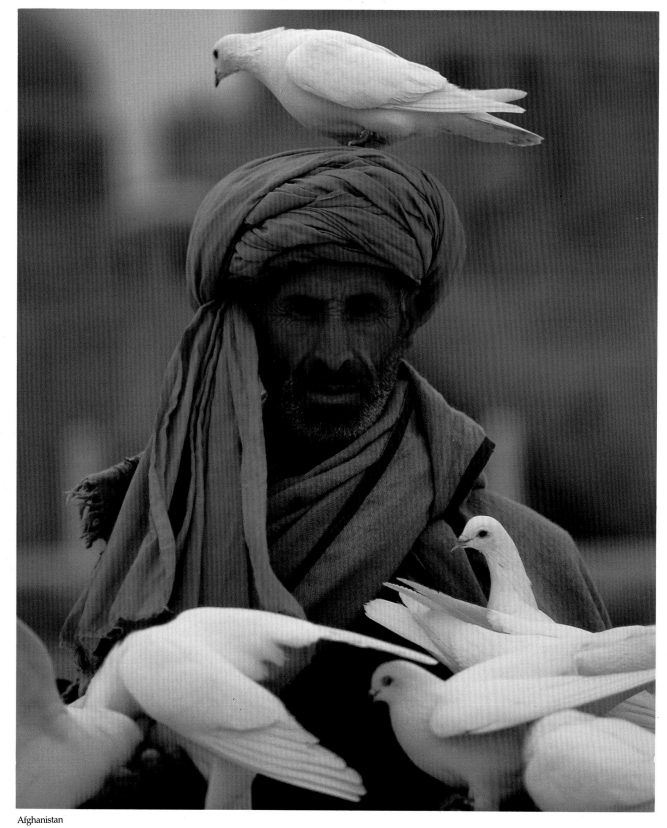

Afghanistan

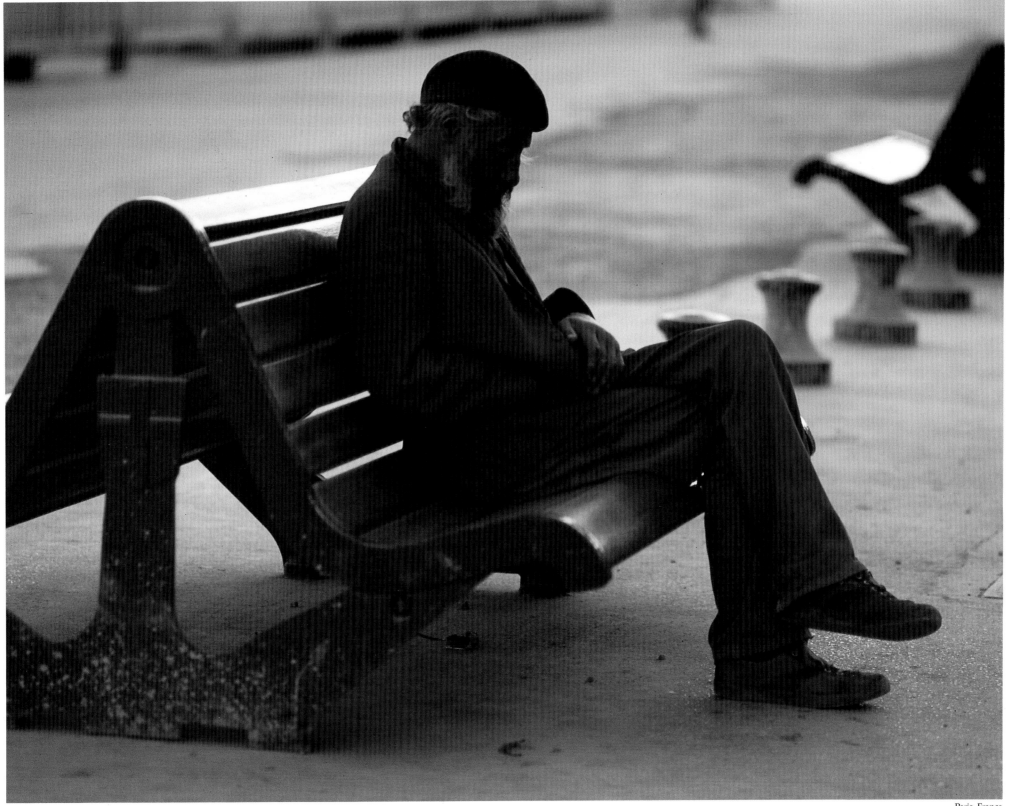

Paris, France

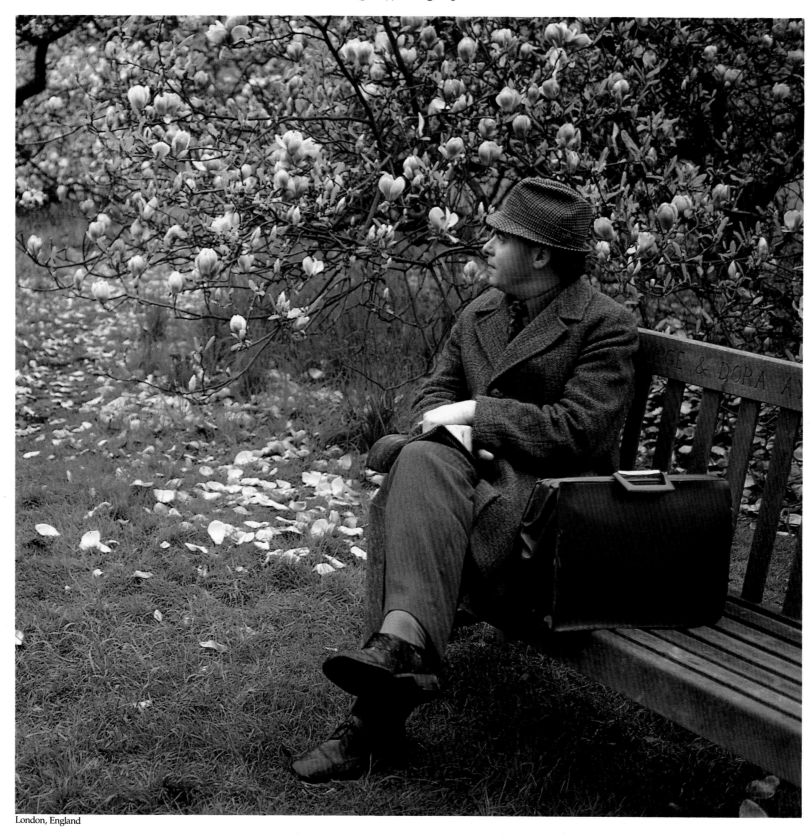

London, England

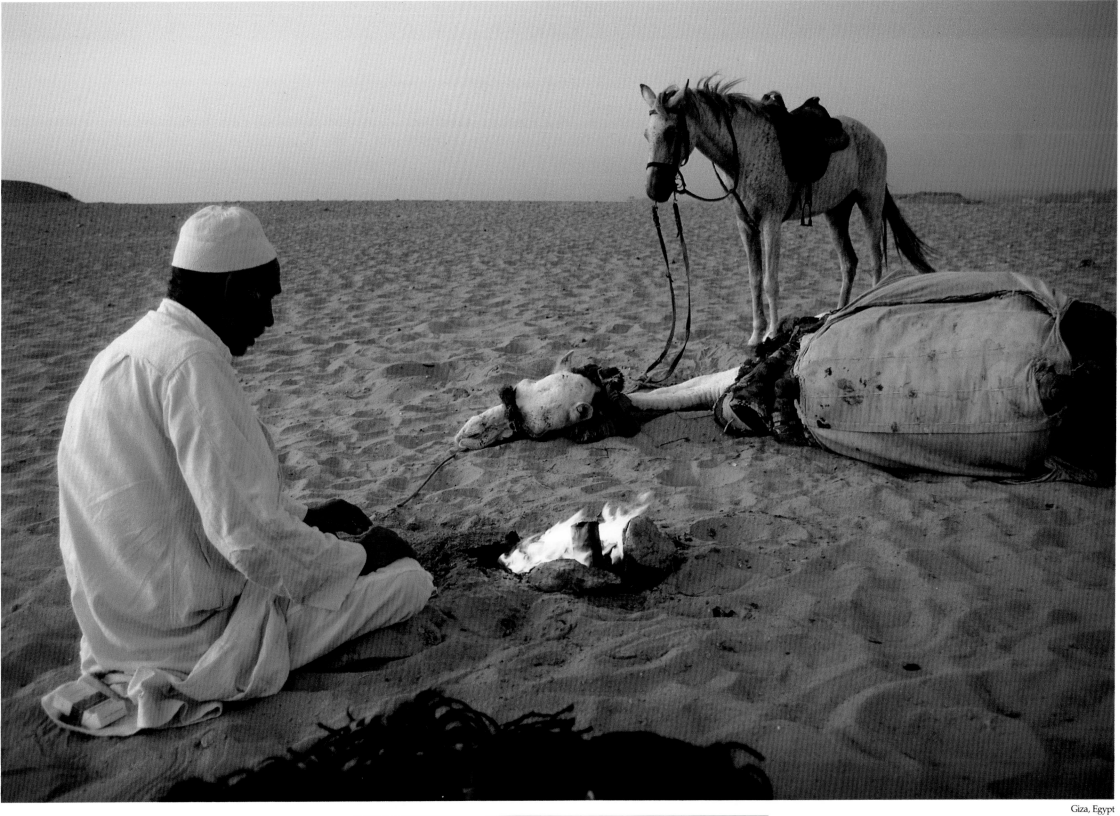

Giza, Egypt

Man says: "How is it possible, when I am dead, that I shall then be brought forth alive?"
Does he not remember that We have created him once, and that he was nothing then?
—THE KORAN

MANKIND, OUR TRUE NATIONALITY

In this last selection of Nagashima's photographs, we see how the old and the young, the old and the new, the traditional and the modern, death and birth exist side by side in the stream of life—the stream that goes on and on, as Kenny Loggins' song says. An older man visits with a younger fisherman, people pray in holy places and one crawls on knees, begging for a cure, a grandmother dies, a child is born, an old couple gaze peacefully toward the future.

The message for leaders in all of these images, we believe, is that we human beings need to attend to each other. We need to be alert to the ways, wants, needs, and attitudes of people we work with or who give us a mandate for political power, since we all share the same habitat and we all want to make it better. Human organizations and institutions need to be developed, or redeveloped, so that they contribute to facilitating lifelong learning, to promoting life-enhancing values, and to improving the quality of life for all of us. Peter Drucker was speaking of business organizations when he said the fol-

lowing, but the idea applies as well to leaders of other institutions, including political ones: "What is most important is that management realize that it must consider the impact of every business policy and business action upon society. It has to consider whether the action is likely to promote the public good, to advance the basic beliefs of our society, to contribute to its stability, strength, and harmony."

We see in these pictures a final evidence of what we share as a people who inhabit the earth together. We can identify with the people in each photographic image because their basic human concerns are also our own. Buckminster Fuller commented, "Now, there is one outstandingly important fact regarding spaceship earth, and that is that no instruction book came with it." Although it is true that we have to *find* the ways to make the world work, we can do it by becoming aware of and affirming our interdependence, taking responsibility for human service, and communicating our concern for each other. As H. G. Wells said, "Our true nationality is mankind."

The way to live our vision on a daily basis is to understand that
right now is the only time we have.
—JOHN HANLEY

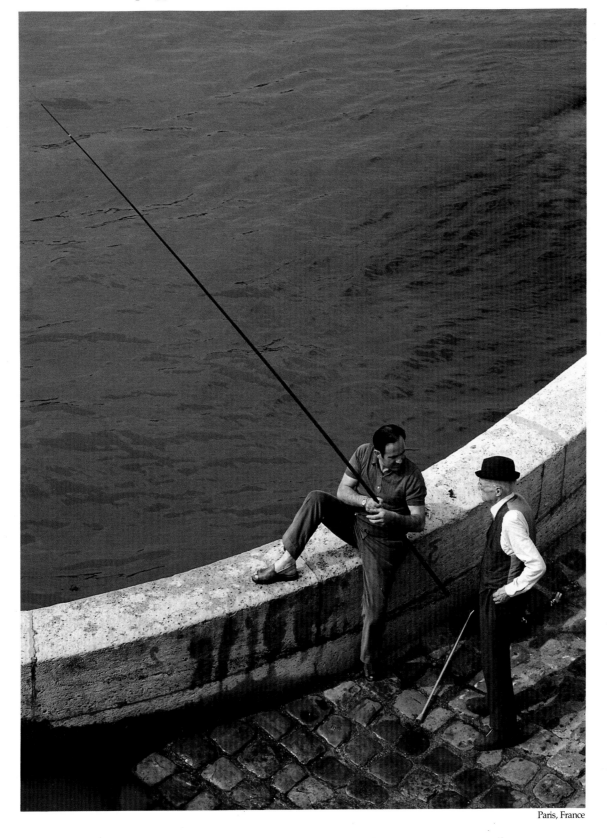

Paris, France

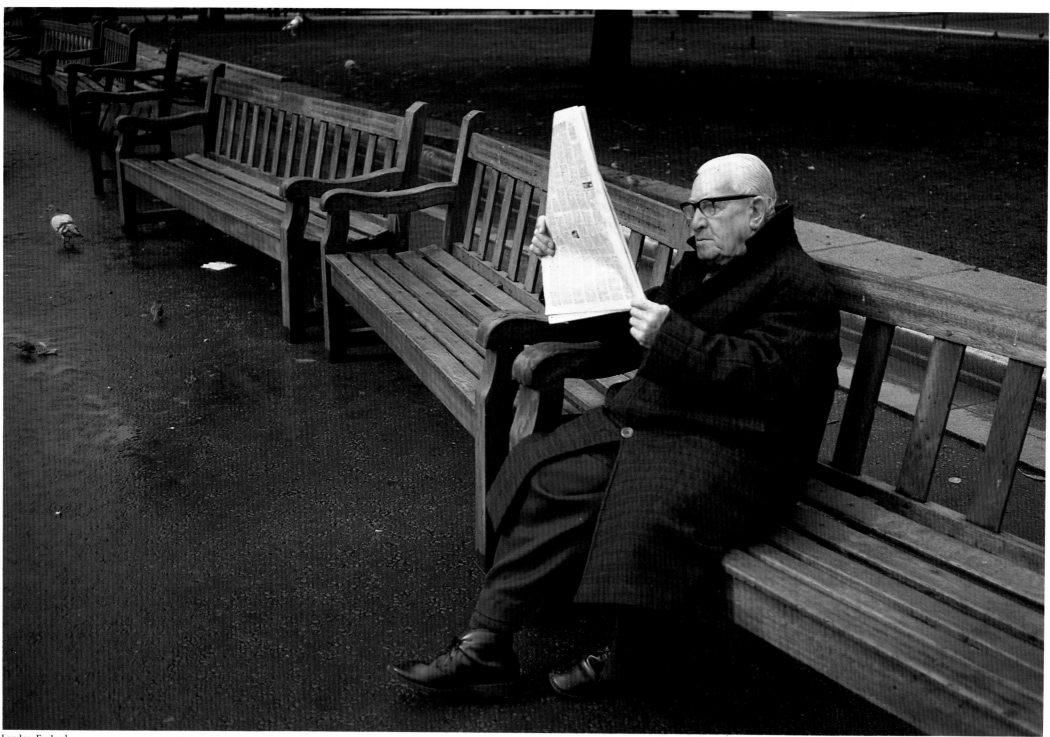

London, England

Experience is not what happens to you. It is what you do with what happens to you.
—ALDOUS HUXLEY

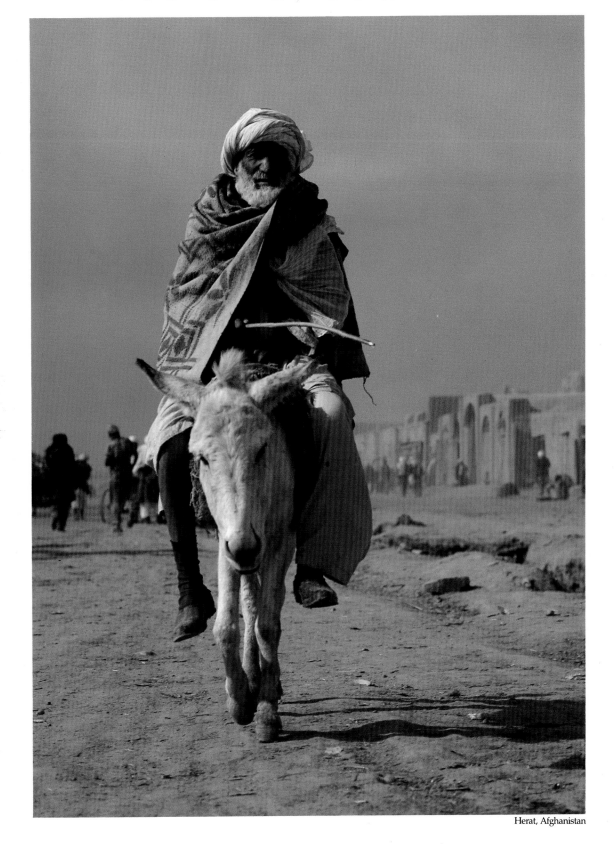

Herat, Afghanistan

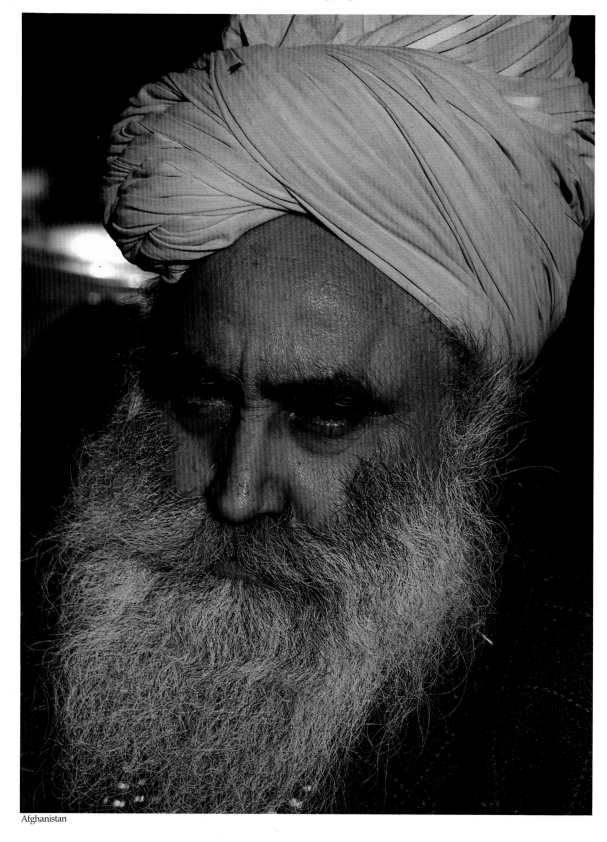

Afghanistan

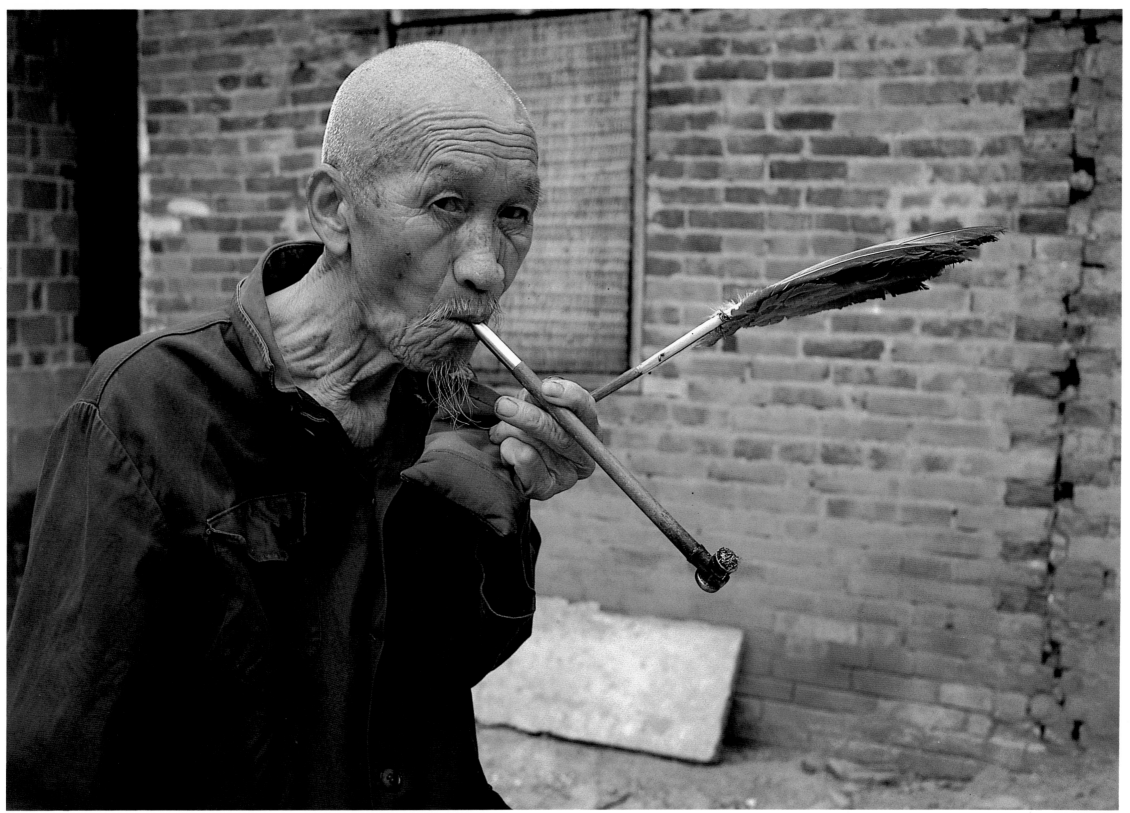

China

As to the best leaders, the people only know that they exist. The next best they draw near to and praise. The next they fear and despise . . . When the best leader's work is done, throughout the country people say, "We have done it ourselves."
—LAO TZU

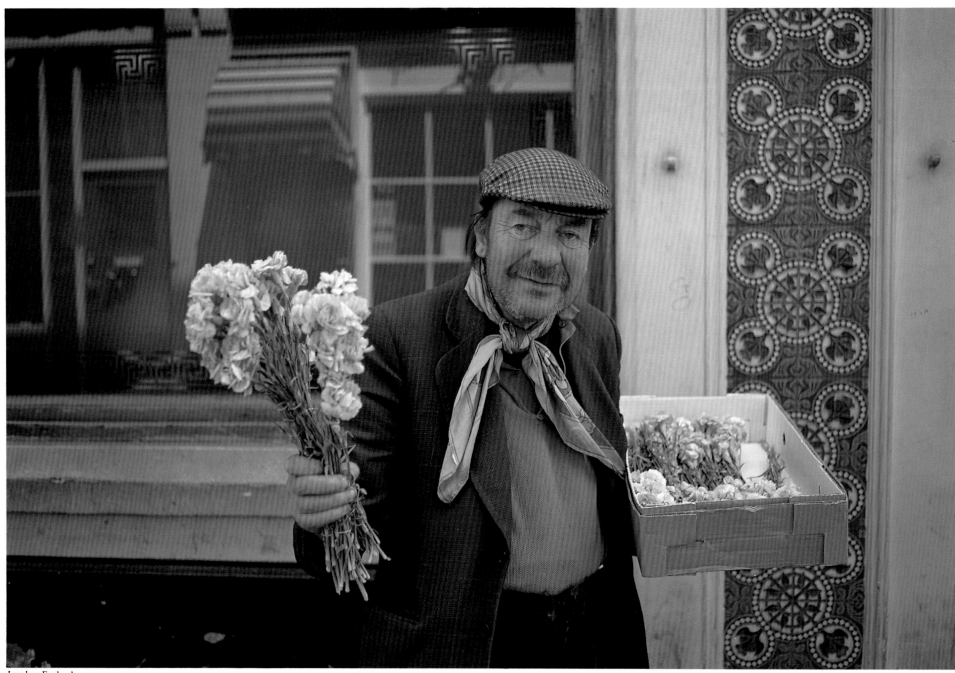

London, England

He who is of a calm and happy nature will hardly feel the pressure of age, but to him who is of an opposite disposition youth and age are equally a burden.
—PLATO

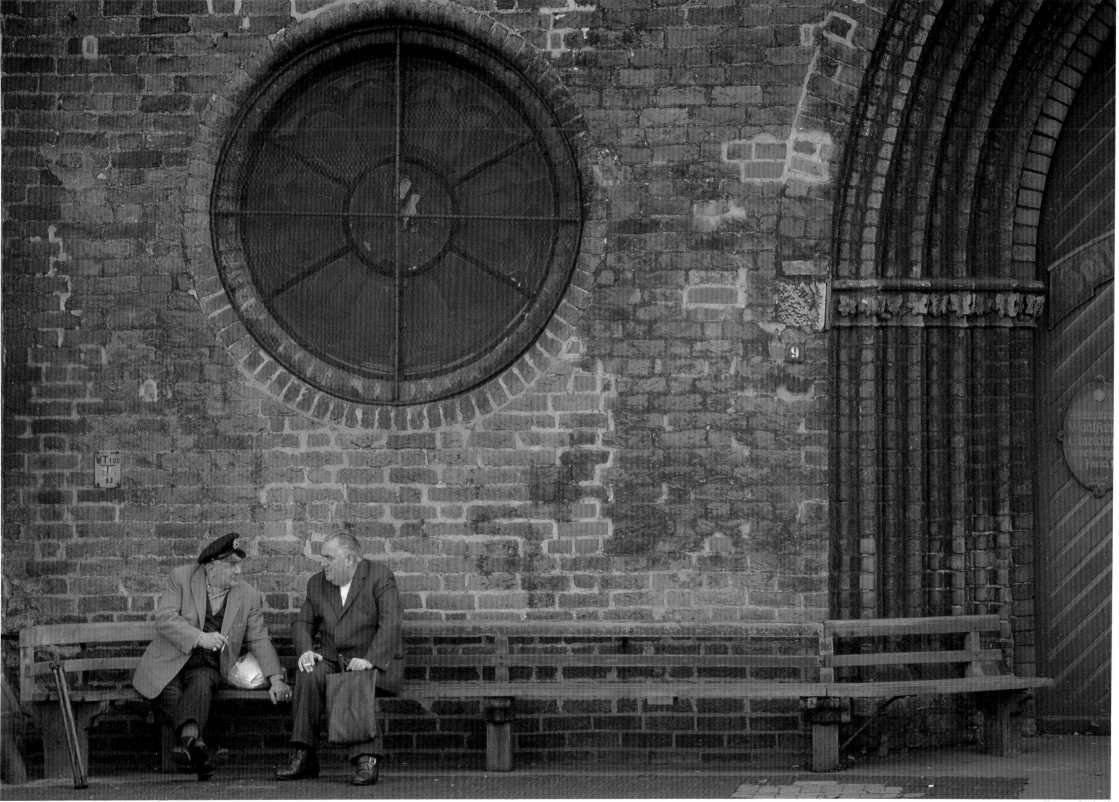

Glasgow, Scotland

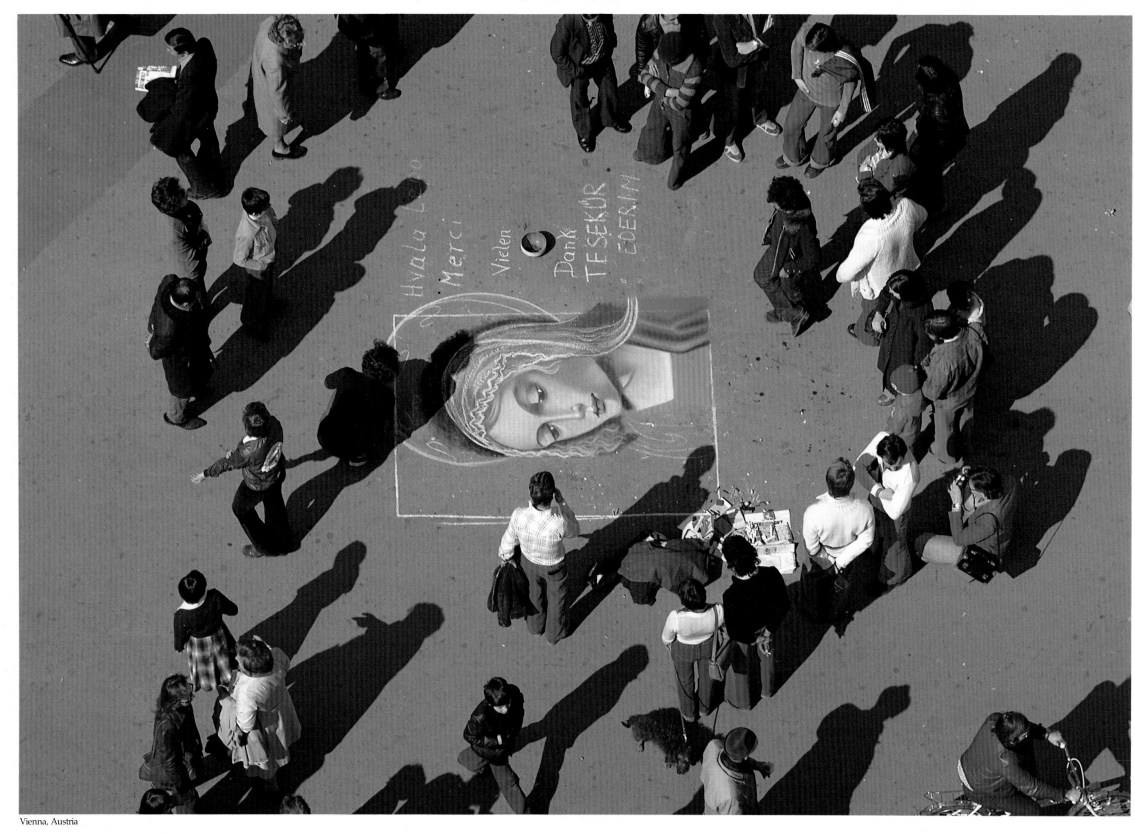

Vienna, Austria

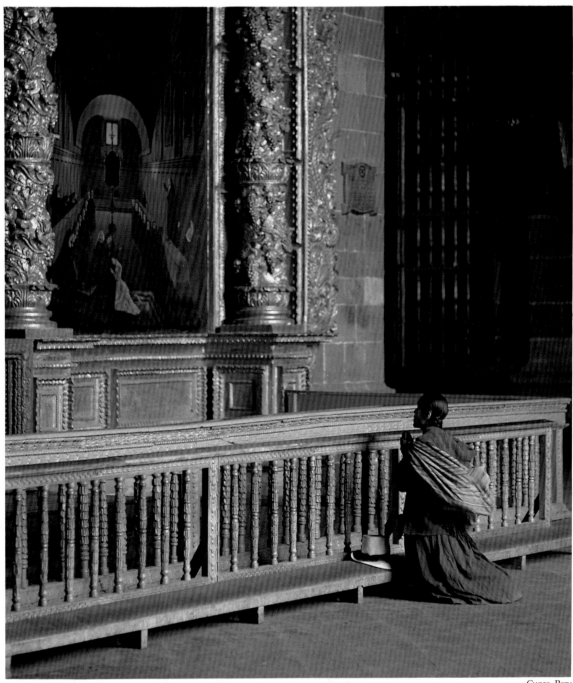

Cuzco, Peru

Render therefore to all their dues; tribute to whom tribute is due; custom to whom custom;
fear to whom fear; honor to whom honor.
Owe no man any thing, but to love one another.
—THE HOLY BIBLE

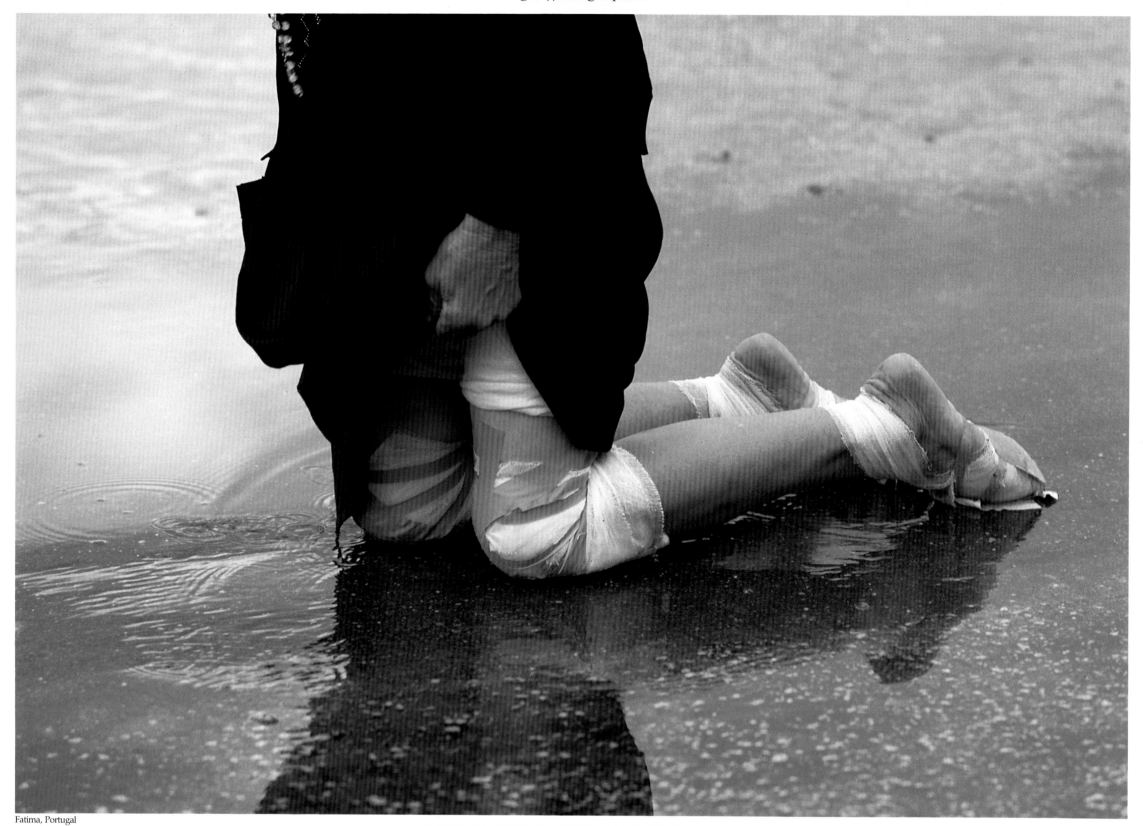

Fatima, Portugal

Our works do not ennoble us; but we must ennoble our works.
—MEISTER ECKHART

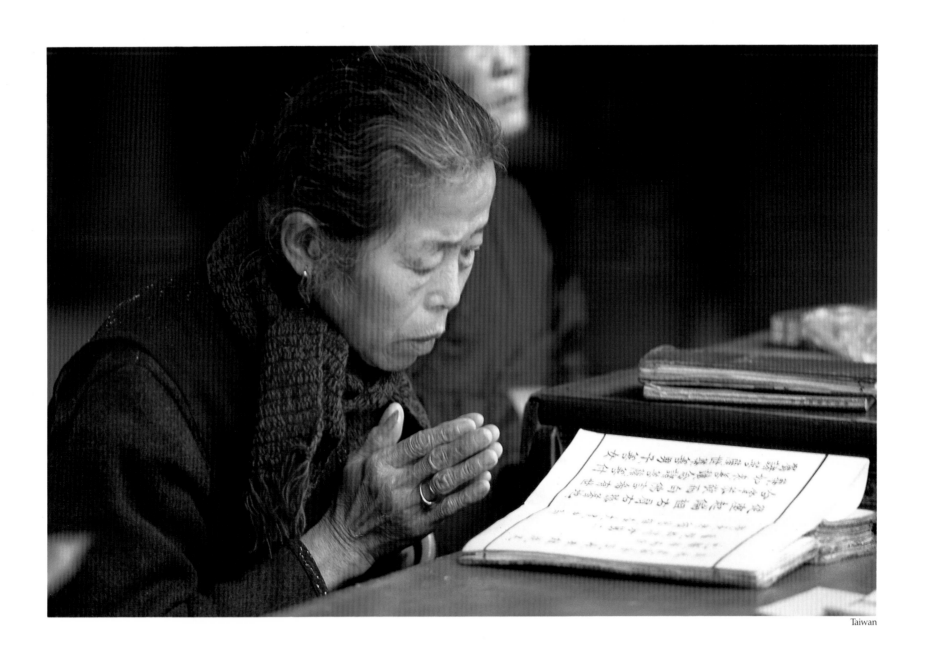

Taiwan

Absolute attention is prayer.
—SIMONE WEIL

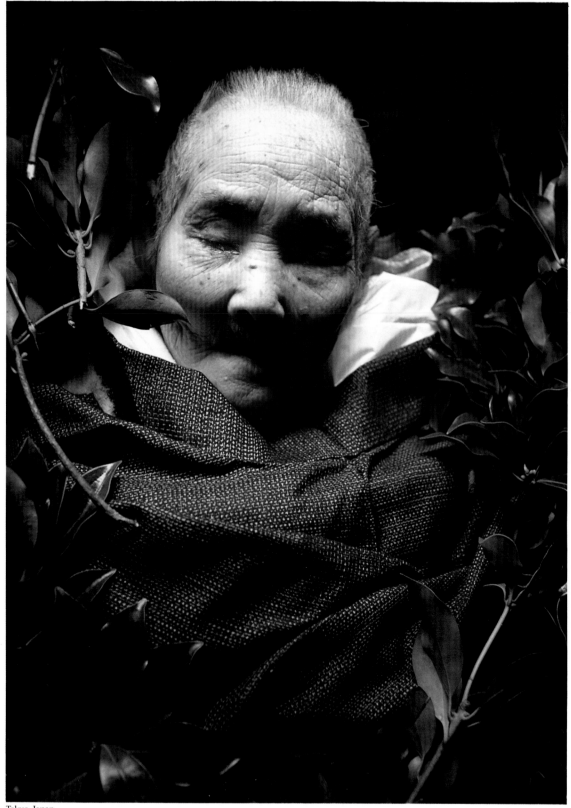

Tokyo, Japan

A certain recluse . . . once said that no bonds attached him to this life, and the only thing he would regret leaving was the sky.
—YOSHIDA KENKO

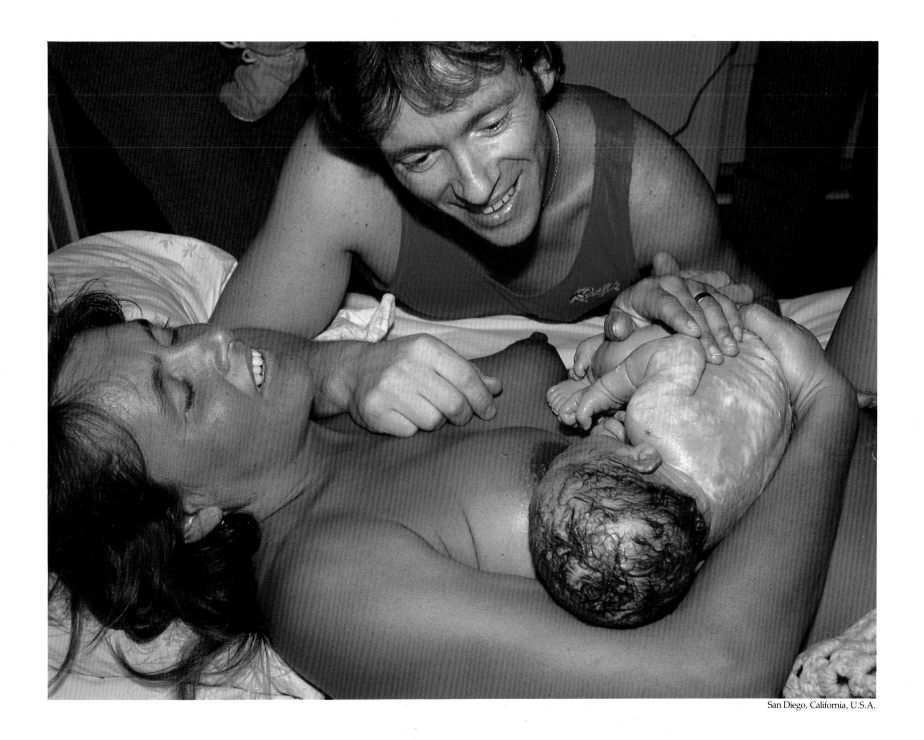

San Diego, California, U.S.A.

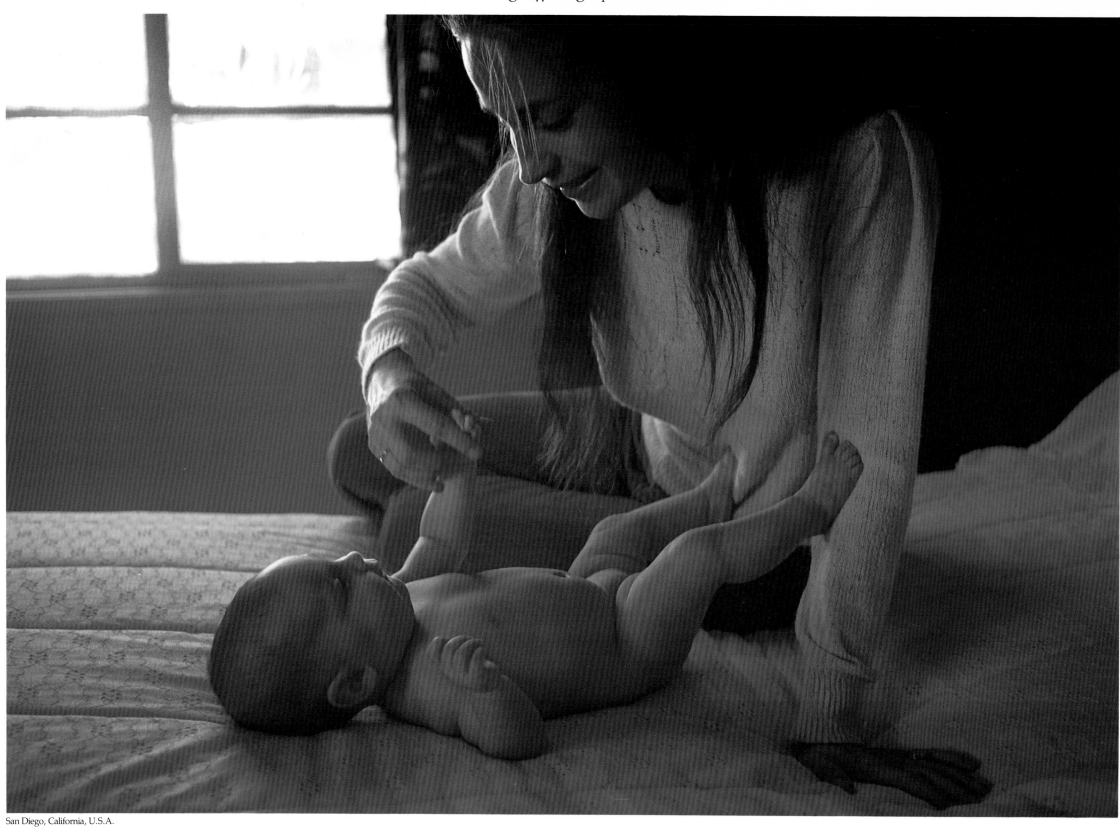

San Diego, California, U.S.A.

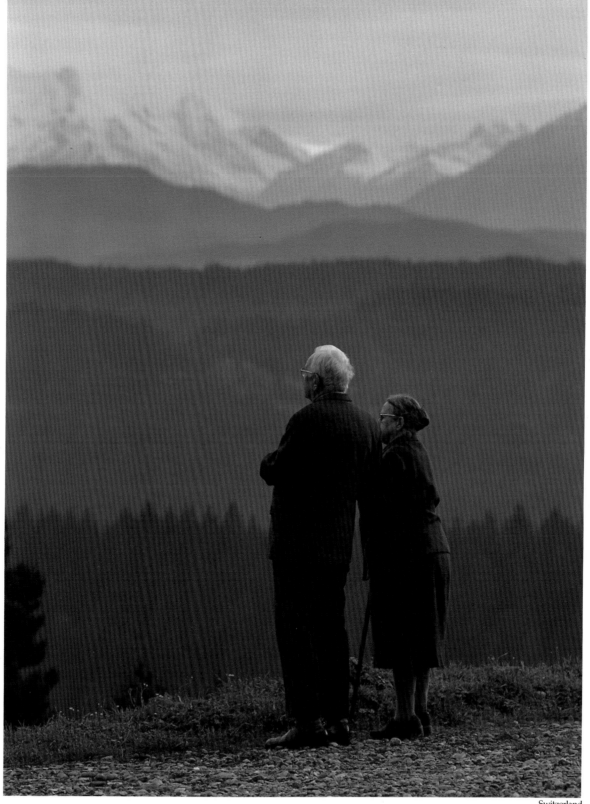

Switzerland

The universe was not made in jest but in solemn, incomprehensible earnest.
By a power that is unfathomably secret, and holy, and fleet. There is nothing to be
done about it, but ignore, or see.
—ANNIE DILLARD

Yoshiaki Nagashima by Mikio Nakayama

Koichi Shimazu by Yoshiaki Nagashima

Robert White by Yoshiaki Nagashima

ABOUT THE AUTHORS

This book was developed by a cross-cultural team: a Japanese photographer, an American businessman who has been living in Tokyo for the past eight years, a Japanese businessman, a management consultant who works in many countries, and a support staff of American designers, editors, a publishing consultant, and a Japanese-American interpreter. This was not a *group*, it was a team, living out the principles contained in the work.

The Photographer. Yoshiaki Nagashima is an unusual professional by any standards. For the past eight years he has made his living selling his own photographs, only accepting commercial assignments if they interest him and fit into his schedule. His international travels continue, and he makes an annual trek to countries he has not visited before. His organization, The Brain Center, is headquartered in Osaka. He graduated from the Nihon Professional School of Photography and is a member of the Japan Photographers Association. He has exhibited in Osaka, Tokyo, and China. He has supplied the photography for several books, including a Senshukai travel series, Bunkasha's world culture series, and a volume on the castles of Europe.

The Writers. Koichi Shimazu is Chairman of ARC International, Ltd., Tokyo. He attended Toyo University and is the author of seven books on leadership and human potential. He is former President of Maruju, Ltd., a worldwide marketing firm with a staff of over 2,000 people. Shimazu is Vice President of the Japan Association for Distribution for Minor Enterprises, Director of the Association for Educational and Cultural Promotion, and a member of the Japan Management Association and the Tokyo American Club. He is known for his personal leadership abilities and as an advisor to corporate executives.

Robert White is President of ARC International, Ltd. He has pursued various entrepreneurial interests in Japan since 1974, where he established ARC International and Life Dynamics in partnership with Koichi Shimazu. He has presented his philosophy to audiences in much of the world, and he was a co-founder of Lifespring (USA). Currently, he is also the Japan Chairman for Republicans Abroad, serves on the Board of Governors of the American Chamber of Commerce in Japan, is a Director of the Association for Educational and Cultural Promotion, and holds memberships in a variety of professional associations. He has been successful in bringing American methods in both management and personal development to Japan.

John Jones is a trainer and organization development consultant with wide international experience. He has worked numerous times with Shimazu and White, their staffs, and their clients in Japan. He is probably best known for co-editing a series of publications on human relations training that is in use in over a hundred countries. He is Chairman of the Institute for Development and Education in Organizations, and he resides in San Diego, California.

John Poppy is president of Poppy Communications, an editorial consulting and production company in San Anselmo, California. He has edited eight photographic books, including *Minamata*, a 1975 National Book Award nominee, and written one, *The Persuasive Image*. He was an award-winning senior editor of *Look* from 1962 to 1970, and was managing editor of *Saturday Review of the Arts*. He was one of the first co-leaders of the pioneering interracial confrontation program developed at Pacific Psychotherapy Associates and Esalen Institute.

ABOUT THE SUPPORT TEAM

The design of this book was developed and coordinated by Don McQuiston and Debra McQuiston, of McQuiston & Daughter, Del Mar, California. Additional design contributions were made by Louie Neiheisel, of Encinitas, California.

Publishing consultant and project manager for the book was Eugene Schwartz, of Consortium House, Del Mar, California.

The consulting editor for the project was Arlyne Lazerson, of Del Mar, California.

The interpreter was Yukara Ohnishi, a linguistic consultant in Oceanside, California.

Production artist was Jana C. Whitney of Del Mar, California.

Additional production assistance by Frankie Wright of San Diego, California.

Typography for the English version was by Boyer & Brass of San Diego, California. The text type is set in Palatino and the display type is set in Michelangelo, both designed by Hermann Zapf and licensed by Stemple.

Color film was by Nissha Printing Co., Ltd., Kyoto, Japan and coordinated by Interprint, San Francisco, California.

Printing and binding was by Dai Nippon Printing Co., Ltd., Tokyo, Japan. The text paper is acid-free 100-pound Espel Dull.

ABOUT ARC INTERNATIONAL, LTD.

This organization's purpose is the achievement of excellence in professional human resource development products and services that enhance the effectiveness of individuals and organizations. Its strategy is embodied in the ARC vision statement: Ideas that lead to greater Awareness, Responsibility, and Communication. Although ARC is based in Japan, its business activities and relationships span the world. Activities include sales of packaged and custom training programs and seminars to corporations; conduct of awareness trainings for both corporate and general public audiences; consulting, recruiting, and executive counseling for direct sales corporations; and planning and promotion of quality meetings.

Published by ARC International, Ltd.

ISBN 4-900422-02-9
Library of Congress Cataloging in Publication Data

Nagashima, Yoshiaki, 1941-
 One world, one people.

 1. Photography, Artistic. 2. Nagashima, Yoshiaki, 1941- . I. White, Robert, 1941- . II. Shimazu, Koichi, 1932- . III. Jones, John, 1939- . IV. Title.
TR654.N334 1984 779'.092'4 84-9189

Printed in Japan